Photographing the Child

Natural Light Techniques for Beautiful, Profitable Portraits

Jennifer George

Amherst Media, Inc. ■ Buffalo, NY

Published by:
Amherst Media, Inc.
P.O. Box 586
Buffalo, N.Y. 14226
Fax: 716-874-4508
www.AmherstMedia.com

Publisher: Craig Alesse
Senior Editor/Production Manager: Michelle Perkins
Assistant Editor: Barbara A. Lynch-Johnt
Editorial assistance from: Carey A. Miller, Sally Jarzab, John S. Loder
Business Manager: Adam Richards
Marketing, Sales, and Promotion Manager: Kate Neaverth
Warehouse and Fulfillment Manager: Roger Singo

ISBN-13: 978-1-60895-590-9
Library of Congress Control Number: 2012953176
Printed in The United States of America.
10 9 8 7 6 5 4 3 2 1

Check out Amherst Media's blogs at: http://portrait-photographer.blogspot.com/
http://weddingphotographer-amherstmedia.blogspot.com/

CONTENTS

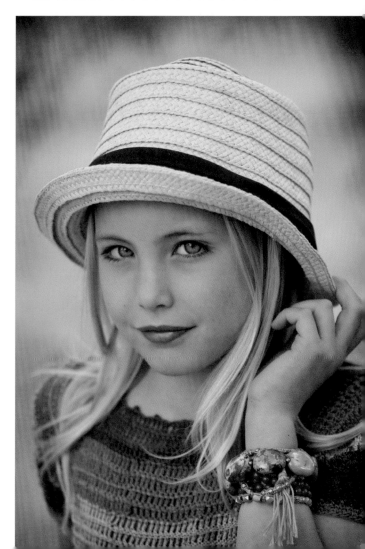

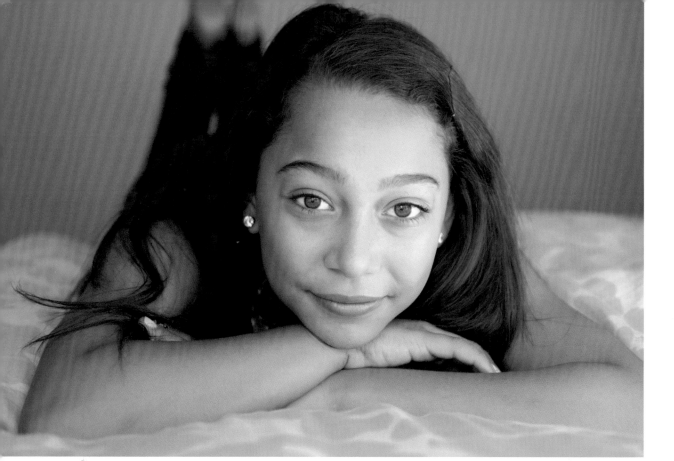

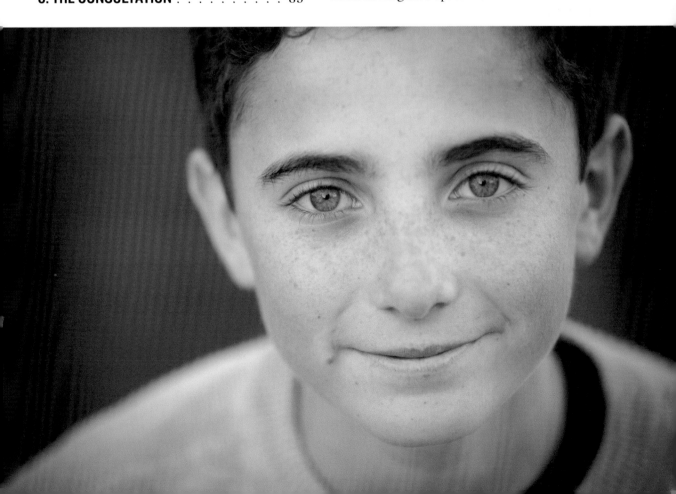

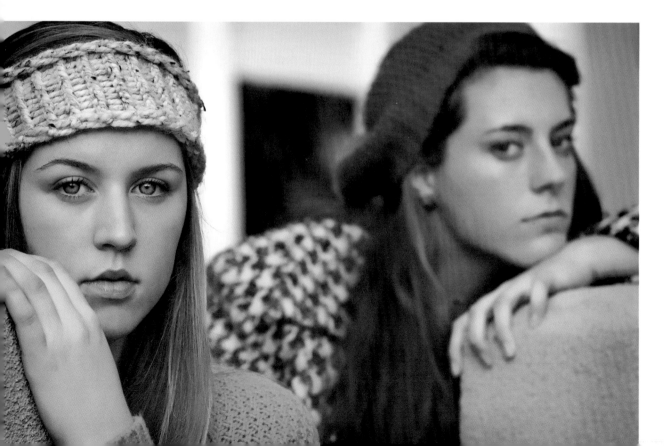

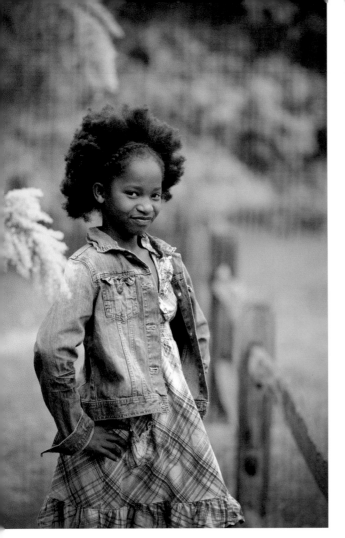
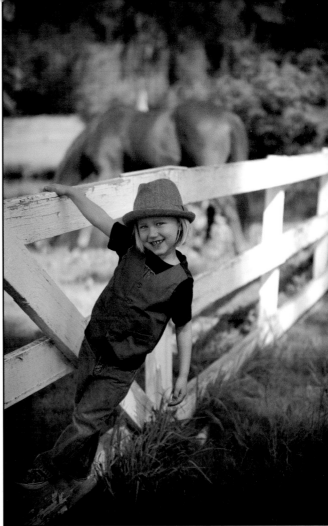

ABOUT THE AUTHOR

Jennifer George has earned a national reputation for her intimate, stylistic portraits. Her subjects are not just clients; rather, her portraits seem to reveal the inner essence of the person. Her soulful images, use of natural lighting, and cultural awareness have afforded her the ability to follow her dream.

Jennifer is passionate about inspiring other photographers to discover their own creative style. After winning California Photographer of the Year in 2001, she was able to travel the state, sharing her distinctive approach to portraiture.

The author and her family. Photo courtesy of Amy Connor.

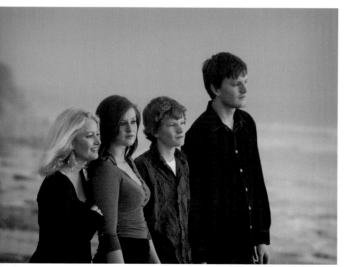

Jennifer taught at the PPA Women in Photography Convention in 2004 and spoke at WPPI for three years. She travels and teaches internationally and continues to guest lecture at colleges, universities, and photographic conferences and workshops in the United States and abroad.

Jennifer completed the print and educational merits needed to earn her Masters from Professional Photographers of America (PPA) in only three years. As a Certified Professional Photographer, she has also obtained her Craftsman with PPA. In addition, seven of her images have been selected for the National Loan Exhibition for PPA, and two additional prints were selected for the PPA display in Seoul, Korea, where she also guest lectured at a Korean university in 2007.

Jennifer's first book, *The Art of Pregnancy Photography,* and second book, *The Digital Photographer's Guide to Natural-Light Family Portraits* (both from Amherst Media®), are available for purchase worldwide. In 2013, Jennifer began taking photography students to orphanages around the world, teaching them photography and showing them how to use their photographic skills to help the needy and give back to communities throughout the world.

INTRODUCTION

WHAT MAKES A GREAT IMAGE OF A CHILD?

Long before I became a professional photographer, there was a moment when I realized how important an image can be to someone. I was on a sales call for a local newspaper I worked for. In this client's very ordinary office, behind his desk, hung an eye-catching photograph. It was a close-up image of a girl swinging her head so that her hair was flying about as if she was in the middle of a hurricane. She was laughing. The photo stood out; it was out of character to the room and its occupant. I couldn't help but ask, "Who is in this photo?" It turned out that it was a photo of my client's daughter, who had died at a young age. He told me that it captured who she was. It was the most precious possession he had.

Over the years, I've photographed hundreds of children of all ages in a variety of situations. Clients often tell me that there is one

Today's portraits are unstructured and have an unposed style—however, there will always be clients who desire a more classical approach. This child's expression helps create a look that is reminiscent of a classical painting. She was lit using only window light.

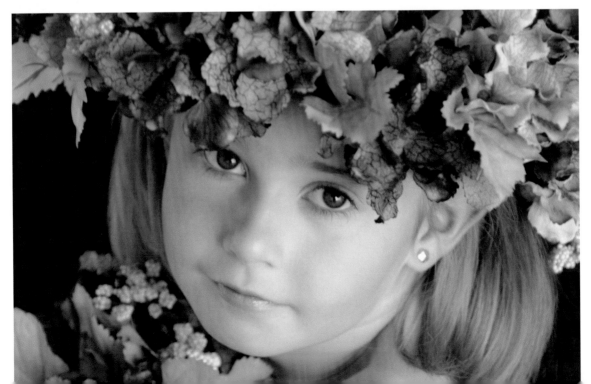

particular image that stands out for them—one that they refer to again and again. It is an image captured in a split second when that child revealed their inner essence to the camera. The image is real and raw, a documented natural moment in the kid's life. It is the parent's most prized possession.

For those of us in love with photography, there is nothing more gratifying than creating an image that moves another human. Creating a stunning image of a child will allow you to do just that. It takes time to learn to create this kind of image, and to do so, you must spend time with the client.

As a professional photographer specializing in family and children's portraits, I've had the privilege of working with and creating thousands of memorable images over the years. Nothing gives me more satisfaction than meeting the families, getting to know them, and creating extraordinary images of and for them. The skills I've acquired have helped me to truly enjoy the experience

■ MILESTONES

As a family and child portrait photographer, you get to see your subjects grow up. There are several families that I have been photographing since the children were very young or even babies. Today many of those children are reaching adulthood. I feel so very privileged to have captured the milestones of their lives.

When meeting a child, determine which features you want to emphasize, then use poses, props, and a camera angle that help you meet that objective. The child wore a white top, and I used a high key lighting setup. The hat drew attention to her beautiful eyes.

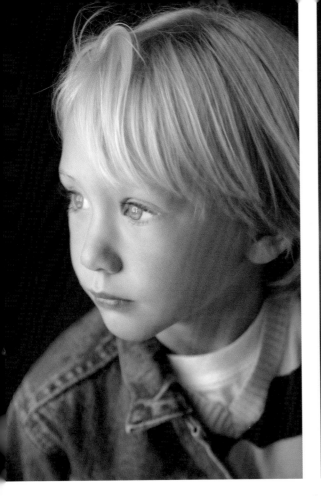

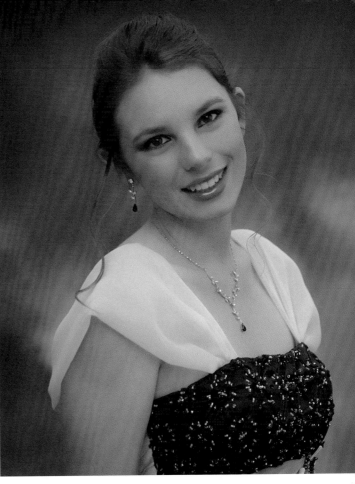

LEFT—During the consultation, I ask parents about the kid's eye and hair color. This allows me to recommend clothing that complements the child's coloration. A simple denim jacket made this boy's beautiful blue eyes pop.
RIGHT—This young lady is from a family I have photographed for years. Here, she was photographed for her high school prom. I was also hired to photograph all three children in the family during their senior year. At the end of the year, I created a book filled with images of each of the young adults' dances, sporting events, and family events.

of photographing children. I have a deep love for teaching, and in writing this book, I've "married" my two loves—photography and educating. In these pages, you will walk along with me, learning techniques to better your photography and your ability to capture those images your subjects will cherish.

ABOUT THIS BOOK

In this age of advanced camera phones and good-quality, low-cost digital cameras, the audience for a book on creating better children's portraits has never been larger. I have designed this book to help the layman, entry-level professional, and even seasoned pro create beautiful, high-quality images of kids, from tots to teens. I will show you how to determine what type of images the client is after, and I'll provide tips for creating a session experience that allows kids to relax, have fun, and be themselves in front of your camera. Of course, I'll also provide lots of technical information that will help you capture the best-quality images possible. As you read these

pages, you'll get inspired by the words and images of some of the top pros in the children's portraiture industry. You'll also get some great ideas for capitalizing on the lifestyle photography movement—so you can take your "studio" on the road and capture kids in their element.

No matter your experience level, you'll find many strategies and techniques that will help make photographing children a little bit easier and increase your odds of success.

Let's get started.

Take your "studio" on the road and capture kids in their element.

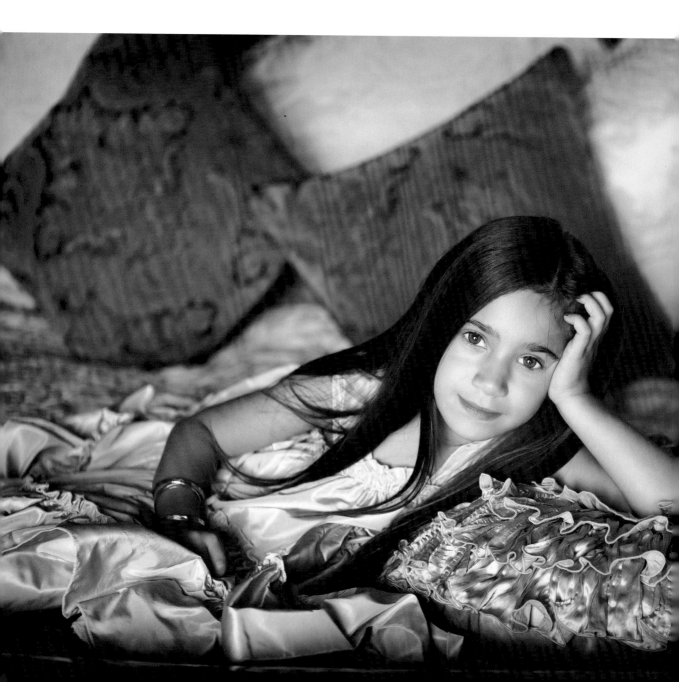

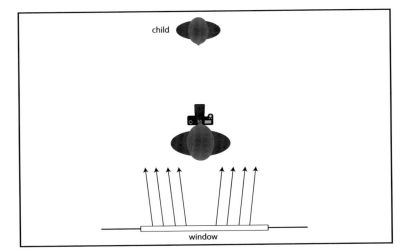

Location can make all the difference in child portraits. Younger children are most comfortable in their own homes. After greeting the family and child, I ask to walk the home and look for the best light. Many times I will ask the child to "help" me find the light and walk with me. In this case, the best light was upstairs in the parents' bedroom. It was fun and easy to have the little lady pose and play on the large bed while I photographed her.

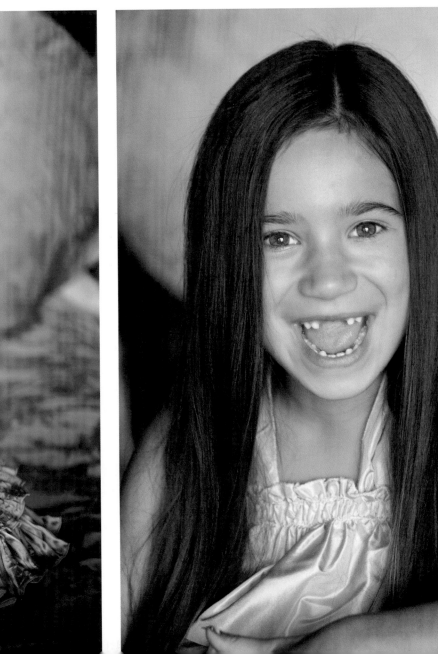

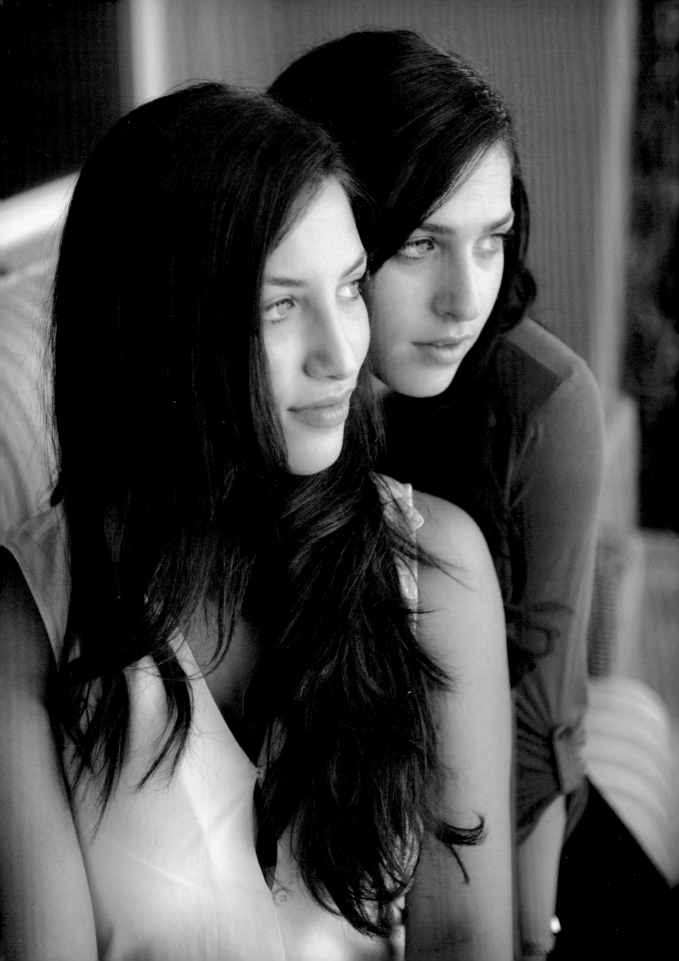

1. THE TECHNICAL STUFF

This chapter addresses all of the technical essentials of photographing children. It is intended to help bring new photographers up to speed and may also be helpful for photographers who want to brush up on the basics.

FROM HOBBYIST TO PRO

A professional photographer can produce superior images correctly and consistently. Getting to this level takes time, education, practice, and dedication. Succeeding in this day and age, when parents have ready access to a digital camera and can produce good pictures, however, means you've got to be at the top of your game. You have to provide a product the parent cannot create themselves—and you have to make producing that portrait a remarkable experience for the client.

I have a passion for working with people and creating artistic, memorable photographs. The images I create are *professional*. I've put a lot of time and energy into becoming a professional photographer. I invested in a strong photography education, and I

FACING PAGE—Your camera position can make all the difference in the impact of an image. Here, the lower camera angle and the girls' poses combine to create a feeling of confidence. **BOTTOM LEFT**—Create intimacy and interest by cropping close to the subject. Here, the subject's head tilt, hand position and grin created a playful, positive vibe. **BOTTOM RIGHT**—To tell the child's story, you'll want to show viewers a little about the subject's world. Here, I chose a shallow depth of field, focused on the child's cell phone, which displayed his photo, and let the background to go soft.

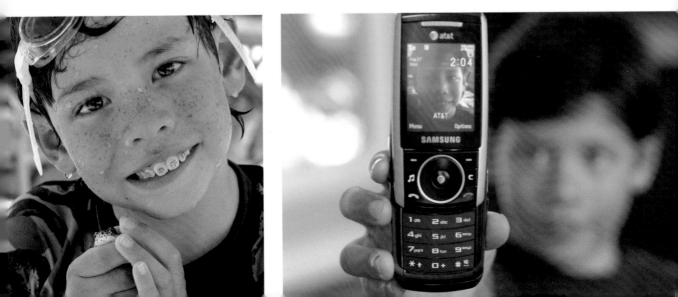

continue to take workshops in order to keep my skills sharp so that I can remain competitive.

My clients value my skills and approach. A repeat client who purchases my "A Day in the Life" session every year has told me that she doesn't worry about taking a camera everywhere she goes or consistently photographing her kids. She feels the "A Day in the Life" session I do for her family provides all the images she needs, so she can relax and "be in the moment" with her kids in whatever they do. She knows that I will capture what the kids look like, who they are, what they love, and their relationships in the family every year, without fail.

To move beyond the hobby level, you will need to invest a bit of time learning basic camera functions and lighting principles. You'll also need to learn how to manipulate your camera settings to achieve the best-quality image possible.

CAMERA SELECTION

If you want to capture professional-quality children's portraits, you'll need to use an SLR (single-lens-reflex) camera—a camera that affords the ability to use interchangeable lenses and manual exposure settings. Digital SLR cameras are called DSLRs.

EXPOSURE CONTROLS

DSLRs offer photographers three exposure control settings:

Shutter Speed. The shutter speed determines the length of time that the image sensor (the camera's image-capture medium) is exposed to light. Fast shutter speeds allow less light to strike the image sensor than do slow shutter speeds.

A fast shutter speed can be used to prevent blur that can result from subject or camera movement. When you're creating lifestyle

Photographer Terri Rippee used a wide aperture setting to throw the tree in the background out of focus. This helps to keep the focus on the subject.

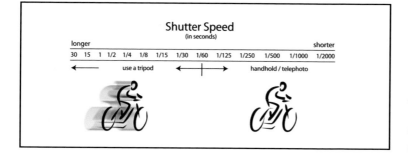

A fast shutter will freeze subject motion, while a slow shutter speed will record the moving subject as a blur.

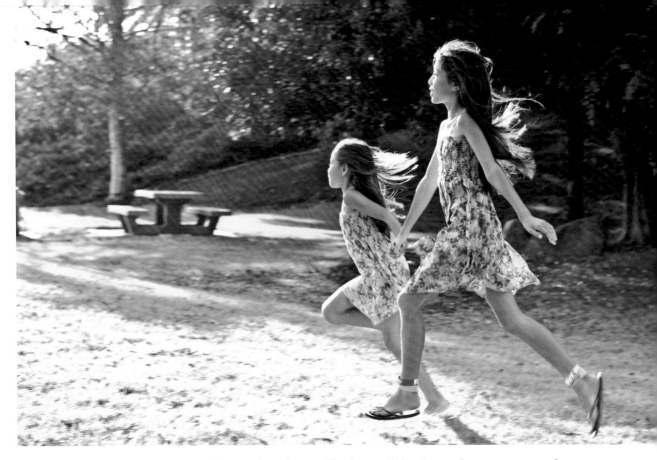

Using a fast shutter speed allowed me to crisply capture these girls mid-sprint. Even their flowing hair was frozen. The exposure was f/5.6 and $^1/_{200}$ at ISO 200.

■ PANNING

Try "panning"—simply choose a slow shutter speed and track a child's movement with your camera as he or she runs across the image frame. This creates an interesting image, as the child will appear in sharp focus, but the background will be blurred.

images (see chapter 7), there will be times when you want to freeze the motion of a young child running or jumping. To do so, of course, you'd choose a fast shutter speed. There may also be times when you want to capture a moving child as a blur, for artistic effect. In that case, a slow shutter speed is in order.

When you are working in a low-light situation, you may need to choose a slow shutter speed to ensure there is enough light to achieve a proper exposure. However, to eliminate the effects of camera shake, you will have to stabilize the camera by placing it on a tripod.

Aperture. The aperture is a variable-width opening in the lens that controls the quantity of light that enters the lens and strikes the image sensor. The size of the opening is described using f-numbers. Small f-numbers (e.g., f/1.4, f/2.8) represent wider openings. Larger f-numbers (e.g., f/11, f/16 or higher) represent narrower openings. Obviously, larger openings allow more light to enter the lens than do small openings.

The aperture also controls the amount of depth of field (the area of the scene, from the front to back, that will appear in focus).

Large apertures (e.g., f/1.4 or f/2.8) produce a shallow depth of field; in other words, only a small portion of the image area is in focus, such as the child's eyes or his face. Small apertures render more of the image area, from front to back, as tack sharp.

As this graphic shows, the aperture becomes larger as f/stop numbers become smaller.

The focal length of the lens also impacts the depth of field you can record. The longer your lens, the shallower the depth of field. If you want the child to be in focus and the background out of focus, then you must use a longer lens (e.g., 200mm) with a large aperture setting (e.g., f/2.8). If you want everything in focus, such as when you're photographing a whole family, you will want to use a shorter focal length lens (e.g., 100mm) or even a wide-angle lens (e.g., 35mm) and a small aperture setting (e.g., f/11). One of my favorite lenses is the Tamron 17–50mm f/2.8. I love using this lens with children and teens, as I can get close enough to them to talk in a conversational style and capture a range of image sizes from just a close up of the eyes to almost full body.

ISO. The ISO number is a rating that describes image sensor's light sensitivity. When a high ISO setting is used, the sensor is more light-sensitive than it is when a low ISO setting is selected. For most applications, an ISO of 100 to 400 is ideal. In a low light situation, you might want to increase the ISO to 600, making the image sensor more light-sensitive. Until recently, photographers were advised to avoid using very high ISO settings, as digital noise (tiny defects that look like colored lights or specks in the shadow areas of the image) would result. However, many newer consumer- and professional-level cameras can be used at ISO 1600 with very little noise resulting.

■ CREATIVE TIPS

1. Depending upon how close you hold the camera to the subject, a wide-angle lens can greatly exaggerate the perspective and produce a wide depth of field. Note, however, that this can cause the nose and chin to appear exaggerated.
2. Use a shallow depth of field to isolate the child from the background and minimize the impact of distracting background image elements.
3. Try a close-up image of the child's face with only the eyelashes in focus.

As a photographer who often conducts sessions in a family's home, I often have to photograph young, fidgety, or energetic children in low-light conditions. A high ISO comes in handy, as it allows me to compensate for the light that is lost when I must use a fast shutter speed to freeze motion. (I'll address exposure compensation below.)

MAKING EXPOSURE ADJUSTMENTS

As stated earlier, the amount of light allowed to strike the image sensor is controlled by the aperture, shutter speed, and ISO setting. When you adjust one of these settings, you reduce or increase the amount of light that is used to make the exposure. With too much light, an image will be overexposed; the subject and scene will appear too bright, and detail in the highlight areas may appear washed out. With too little light, the image will be underexposed; the subject and scene will appear too dark, and detail in the shadow areas may be lost.

With every one-stop (or one-step) change in an exposure setting, you double or halve the amount of light that is being recorded. To maintain the desired exposure, you must adjust another setting to halve or double the amount of light striking the sensor. Let's look at an example: If you have metered your scene and have dialed in your exposure settings—say f/2.8 and $^1\!/_{60}$ at ISO 400 but decide to use a smaller aperture, f/1.4, to reduce the depth of field, then you will have allowed twice as much light to strike the sensor. To maintain the exposure, you could dial the ISO down a notch to ISO 200, or you could increase the shutter speed to $^1\!/_{125}$.

THE BEAUTY OF MANUAL EXPOSURE CONTROL

Today's digital cameras offer automatic exposure modes that allow you to capture a "correct" exposure for an average image. To do so, the camera relies on a built-in meter that measures the light levels in the scene you are photographing. The built-in meter—*all* meters, in fact—assume that a scene will have a normal tonal distribution. When the scene is not average, the camera will seek to remedy that situation. If you try to photograph a scene with predominantly light tones, the camera will think "too bright!" and

■ EXPOSURE TIPS

1. Overexposure gives you a brighter image. You can overexpose an image by choosing a wide aperture and a slow shutter speed.
2. Underexposure gives you a darker image. You can underexpose an image by choosing a small aperture and a fast shutter speed.

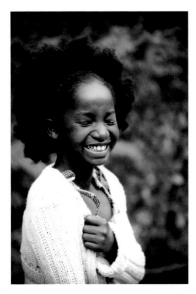

Capturing a correct exposure will allow you to maintain detail in the highlights and shadows.

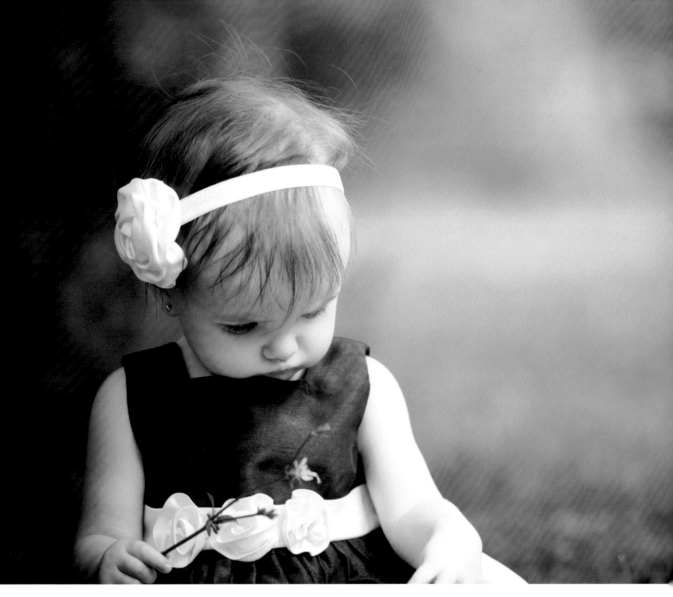

will recommend settings that reduce the amount of light striking the image sensor. When the camera takes a reading of a scene comprised of darker-than-average tones, the camera will deem the scene too dark and will recommend settings that allow the sensor to receive more light. The result, of course, will be an overexposed image.

Exposure Compensation. When you understand how exposure works, you'll want to practice using exposure compensation. With experience, you'll be able to "read" a scene and decide if it needs more or less light than an in-camera meter might recommend.

There is more than one way to correct for an off-the-mark exposure reading. Rather than manually changing your shutter

Rebecca Lozer finds that small children are naturally curious, fun, and have a very short attention span. She recommends that you find an interesting object—say, a flower or a twig—for the subject to interact with in the image. Not all photos need to show the subject smiling. Pensive and somber expressions are captivating too—and Rebecca is invested in taking the time needed to capture such shots. Photo by Rebecca Lozer.

speed, aperture, or ISO, you can take advantage of your camera's exposure compensation feature.

I recently photographed children of different ages and skin tones for an event held at a park. I wanted to capture at least one image of every child. If I relied on my camera's internal meter and did not compensate, the images of children with very fair skin would have been underexposed, and the images of children with darker skin would have been overexposed. I used the exposure compensation button on my camera to adjust for the extreme skin tones.

LENSES

Lenses can be classified into two categories: fixed focal length (prime) and variable focal length (zoom). As a rule of thumb, the larger the maximum aperture of the lens, the higher the quality of the lens and the steeper the price. For the photographer on a budget, a variable focal length lens is the best investment. The zoom lens will give you a variety of focal lengths (e.g., 18–35mm, 17–50mm, 24–70mm, and 70–200mm). For years, the standard telephoto lens, 70–200mm f/2.8, was the go-to lens for most portrait photographers. This lens allowed for a compressed depth of field, making beautiful family portraits that had the subject in focus in the background slightly soft and blurry. Today, portrait photographers use the 85mm f/1.4 or f/1.8 (depending upon the manufacturer) and the 24–70mm f/2.8. Both lenses capture clear images where the subject is sharply in focus and the background falls off to a pleasingly soft blur. *(Note:* As I mentioned above, the longer the lens, the more compressed the depth of field. If you use a short focal length or wide-angle lens, your depth of field will not be as shallow as it will be with a longer lens at a given aperture. With a short or wide-angle lens, then, it can be difficult to capture an image of a child where just the eyes are in focus, and the focus falls off quickly.)

The focus points of lenses vary from one manufacturer to the next. I recently rented an 85mm lens only to find out that I had to be at least 3 feet away from the subject for the lens to focus. This was very frustrating to me because, when photographing kids, I want to get in close to shoot select areas of the face.

■ GET UP CLOSE

Get up close with a wide-angle lens. Stand above the child and shoot down over the profile using a wide aperture (e.g., f/1.4 or f/2.8) for a shallow depth of field.

KNOW YOUR CAMERA

The most important tip I can offer is that you should learn how to use all of your camera's functions, without hesitation. Your camera should become an extension of yourself. When you have reached

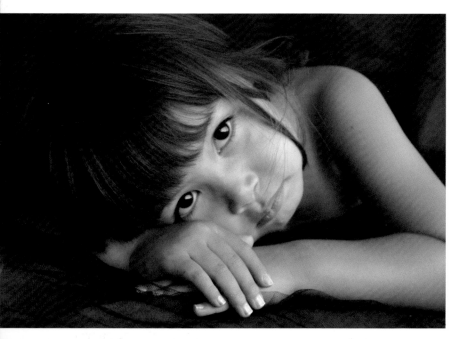

LEFT—The eyes and solemn expression make this portrait a keeper. Try to capture a range of emotion during the session. Not all portraits need to show the subject smiling. **BELOW**—In order to capture perfect light on a small child, Rebecca Lozer uses the parents or a toy to get the subject's attention in the direction she wants. She says, "Knowing where to place your subject and understanding light is key to a successful image." Photo by Rebecca Lozer.

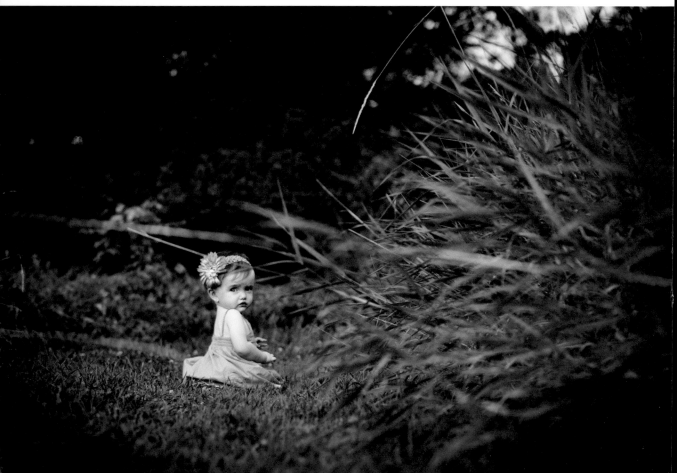

Just Hanging....

My "A Day in the Life" albums are filled with images of families engaged in all of the activities that make up their days.

■ PRACTICE

1. Practice changing your camera settings when you're not shooting.
2. Try shooting in locations with different levels of light. Set your exposures manually.
3. Check to ensure that the exposure of the images you see on your LCD screen matches what you see on your computer monitor (assuming that your monitor has been calibrated). If the two do not match, adjust the LCD brightness in your camera to match the image you see on your monitor.

that point, you won't have to stop to look at the settings on your camera. This is particularly important in lifestyle photography and with young children, as photo-worthy expressions and special moments are often fleeting. You should be able to adjust your aperture and shutter without looking at the controls, while the camera is aimed at the subject.

WHAT'S IN MY BAG

A professional photographer must be ready to create the kind of images their clients want—and images that they've dreamed of. To meet that goal, I keep the following equipment in my camera bag:

- cameras: Nikon D800, Nikon D2x
- lenses: Tamron 70–200mm lens, Tamron 17–50mm, Nikon 24–70mm lens, Nikon 50mm lens, and Nikon 18–35mm lens
- accessories: duck whistle, finger puppet, baby rattle, duct tape strips, large paper clamp, extra batteries, CF cards, and SD cards
- Westcott reflector kit. This kit includes soft gold, gold, silver, white, and black panels. The panels can also be removed and the unit can be used as a diffuser.

A PRO'S VIEW
MARC WEISBERG

"A camera is a camera, " says Marc Weisberg, a Lo Angeles-based professional photographer and owner of Marc Weisberg Photography in Tustin, CA. "Put it in the right hands, and photo magic can happen. An ability to produce that magic consistently, instead of coincidentally or sporadically as a happy accident, is what separates an amateur from a pro."

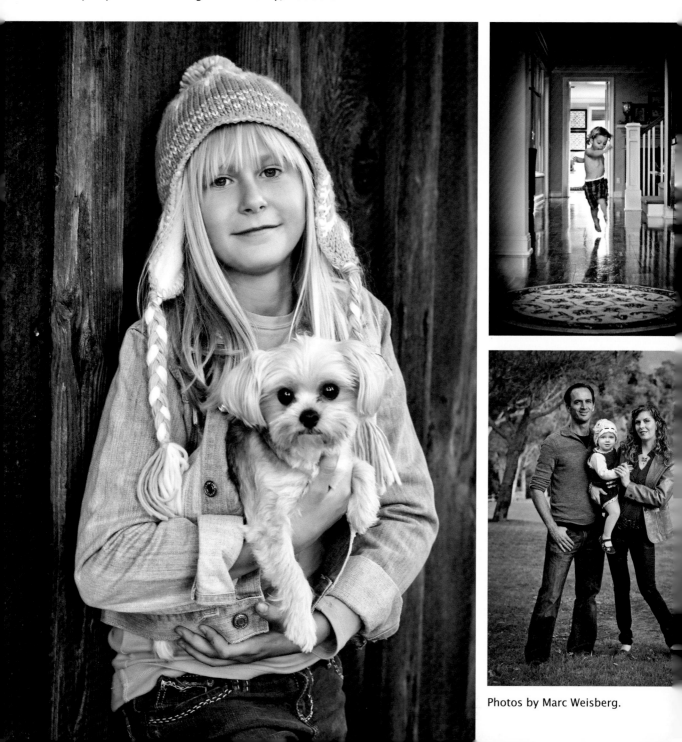

Photos by Marc Weisberg.

2. GETTING STARTED

It takes a special type of person to want to do this for a living.

ARE YOU SURE YOU WANT TO DO THIS?

Photographing children is definitely not an easy job. You will be in for a wild ride every time you photograph or work with them. It takes a special type of person to want to do this for a living.

In addition to the inherent challenges of working with clients, there are financial concerns that the digital revolution has brought about. In the past, only a portrait studio could document the precious stages of a child's life. Now, aspiring photographers with decent cameras sometimes take on the task. In this declining economy, parents don't have the discretionary income they once had to buy "luxury" items like portraits. This means there are fewer clients who are seeking the services of a professional photographer.

There is also more competition than ever before—and upstart business owners sometimes undercharge to get clients in the door, making it difficult for those who ask a fair price to stay afloat. Kim Treffinger, owner of Treffinger Studio, a successful studio in the San Diego area, feels that selling digital files at a low price has had

The terrible twos are definitely the most difficult age to photograph. You will need an enormous amount of patience, ingenuity, and quick reflexes to capture even one decent image! Props usually help. Here, I used the "hip" grandmother's glasses to create an adorable photo of the granddaughter that had meaning for the parents and grandparents alike.

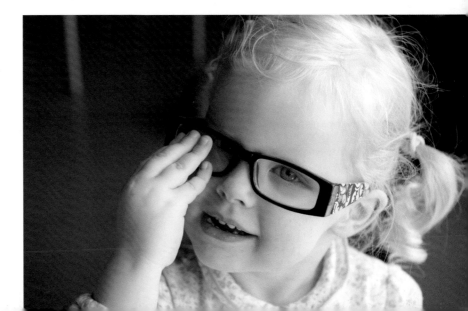

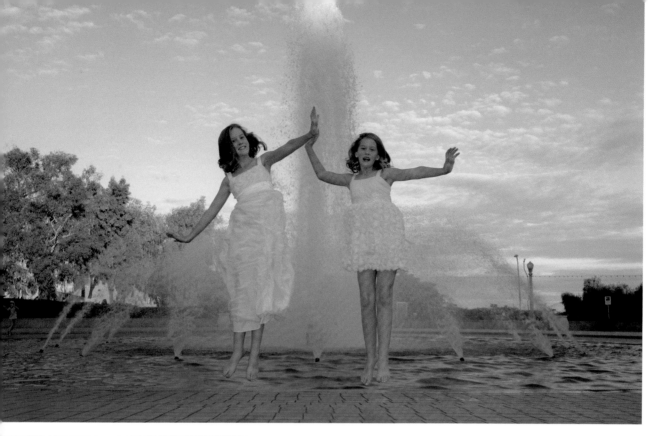

Child portraiture is no longer just classical still photography made in a studio. Today, you must also be a photojournalist. While it takes a bit of practice to anticipate movement and action for the best unscripted images, it is very rewarding when you do capture unrehearsed moments in a child's life.

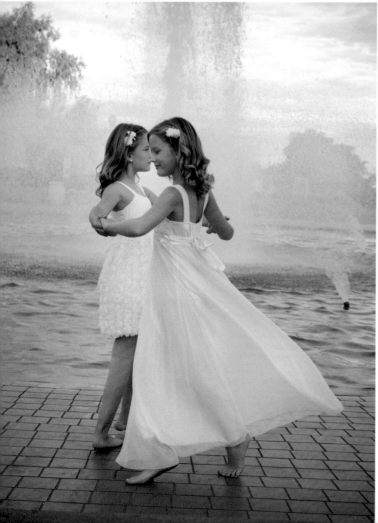

LEFT—This session was held on a rainy day, and I was forced to do the session in a tiny apartment with only a sliding glass door for light. Luckily for me, my Nikon D800 does a superb job at a high ISO. This image was captured at an ISO of 1600, a shutter speed of $^1/_{125}$, and an aperture of f/3.2. A black panel was used as the backdrop. I had the child face the sliding glass doorway while I stood on the patio with the doors open. RIGHT—To capture those adorable spontaneous smiles, have the child play, dance, skip, and move. All the while, watch closely. In the midst of the action, call the child's name to get her attention—then capture the natural moment.

a negative impact on the portrait industry. She says, "The advent of discount group buys such as Groupon appeals to clients looking for the lowest price possible and discourages client loyalty, as the clients will be looking for the next best group deal possible. This artificially lowers the pricing for portrait photography. The majority, some estimate 90 percent, of the entry-level photographers starting a business will no longer be in business in one year."

THE EVOLUTION OF CHILDREN'S PORTRAITURE

When you start out as a photographer, you need to decide what direction you want to take your business. In the past, the typical photography studio earned the majority of their income from family, high school senior, and business portraiture. Studio photographers used large format cameras, which had to be mounted on a tripod and were difficult to move. They weren't well suited to photographing children who, by nature, don't seem to like to remain still for long. When 35mm SLR (single-lens reflex) cameras became available, things began to change. It was possible to move and to capture the adorable expressions of young children and babies.

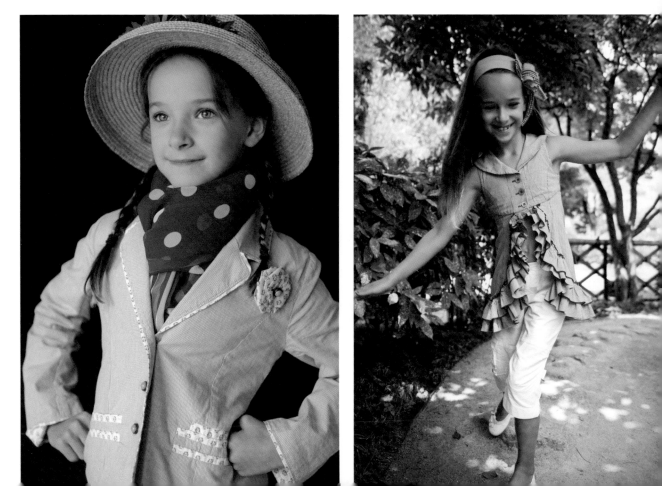

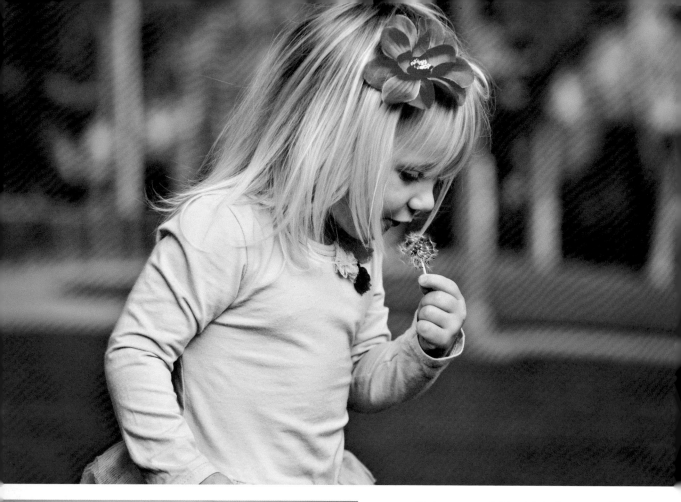

ABOVE—To be successful in this industry, you've got to be good with kids. When you're able to make them feel comfortable, you'll be rewarded with portraits that are full of personality. Photo by Marc Weisberg. LEFT—This portrait was made as part of a family beach session. The puppy, Lacey, was a brand-new family member, and everyone was excited for her first family portrait. Getting faces close together helps to highlight the expressions and emotion for a tight shot. Photo by Kim Treffinger.

Today's DSLRs (digital single-lens-reflex cameras) make it possible for even amateurs to create decent images of their children. The technical aspects of photography have become easier than ever before, allowing for a more artistic approach to capturing images. Like most photographers, I want to be an artist, not a technician. The digital camera has allowed me to express myself and capture my subjects' emotions in ways I was not able to with a medium format or film SLR camera.

I believe that professional photographers who take the time to learn a foundation of art, design, business, technical skills, and a little psychology will find a bright future. But that's not all that's required. Besides fine-tuning and excelling in these related areas, a professional photographer will have to create an image and brand of his or her own to stand out from the entry-level shooters.

Specializing in photographing children or adding it to your repertoire can lead to continued growth and a guaranteed clientele. When I started out, I used a medium format camera mounted on a tripod. I found this to help immensely in growing my technical

A captivating pose for these teens, warm lighting, and great expressions combined to make this a standout professional portrait. Photo by Jason Romero.

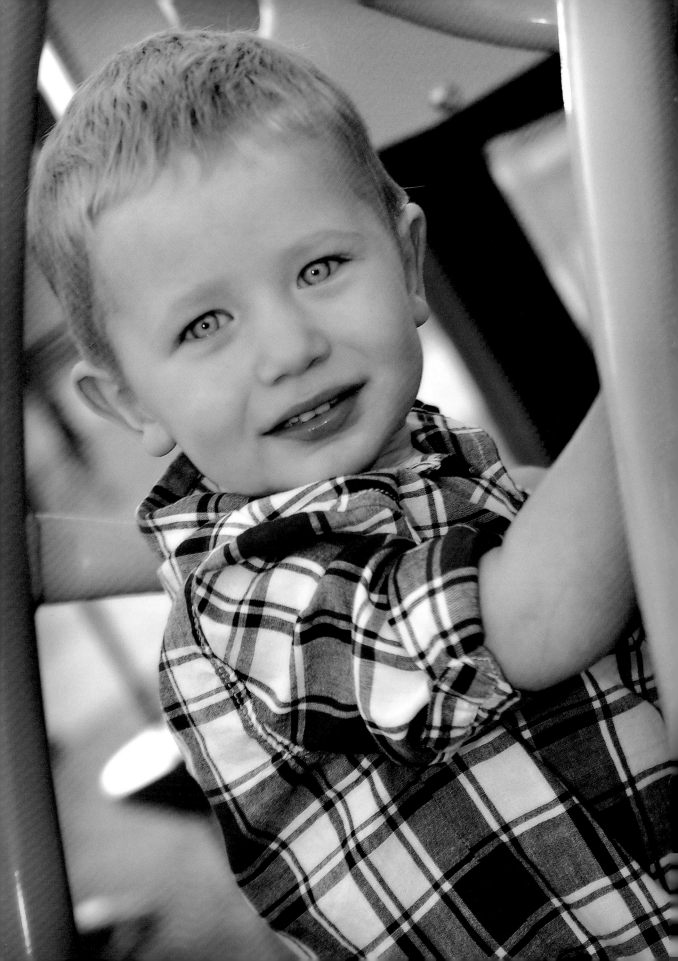

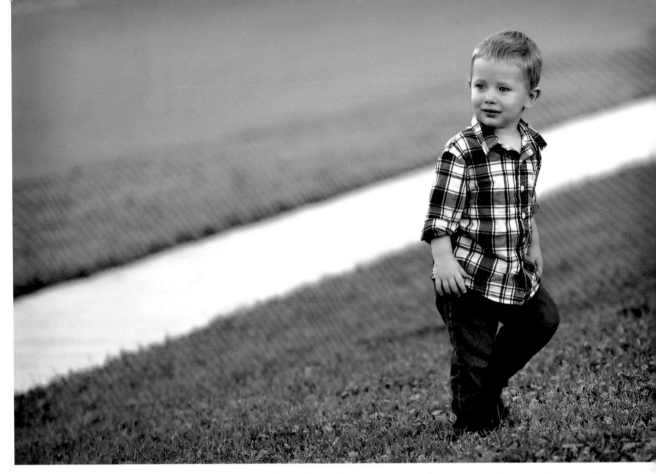

FACING PAGE AND ABOVE—It's important to create a brand that helps your work stand out. Photos by Mike Strickland.

■ RULE YOUR ROOST

Dave and Ally McKay of El Dorado Hills, CA, have been creating museum-quality family portraits for years. They have a well-established studio, McKay Photography, and can dictate business hours that work for their family. They offer sessions Monday to Friday during business hours only. This creates the perception that they are exclusive artists and in high demand.

expertise. A medium format camera forces the photographer to gain an understanding of lighting and exposure. When I switched over to a 35mm film camera, the technical skills that I had developed helped me create exceptional images. With the SLR camera, I could move more freely. This gave me the flexibility to capture more emotional images of my subjects.

I have spent a great deal of energy building relationships with my clientele, with plans of keeping them as clients for a lifetime. I am a portrait photographer, not a wedding photographer; therefore, most of my clients came to me when their children were babies. Once I mastered the ability to work with children, I was able to build my business based on my public reputation. In fact, one of my best clients, who has been with me throughout my entire career, came to me when her oldest child was 2 years old. She had heard that I could photograph difficult babies. As it turns out, the little one cried the entire time, but my calm demeanor relaxed the parents, and I was able to take wonderful images while the parents comforted her. Those images made them clients for life.

FOR THE PRO, EXPERIENCE MAKES THE SESSION

In this highly competitive market, you need to ensure that you are doing all you can to sustain your business and make a profit. Marc Weisberg has found that there are three factors that have changed the business of children's portraiture. First, he feels that the slow-down of the economy has dramatically impacted clients' ability to purchase luxury items such as professional portraits. Second, he notes that customers are looking primarily for digital image files instead of prints. Marc says, "As a photographer, if all you do is shoot and burn, you will never have a clientele that is willing to spend more because you are conditioning them to get a disc of im- ages instead of wonderful framed wall portraits." Third, like most professional photographers, Marc's studio has been affected by the proliferation of entry-level photographers who have little techni- cal or business experience yet are competing with professionals for clients.

Professional portrait photographers have begun to realize that the portrait experience is a big factor in winning clients. From the moment you have contact with the client to the moment you

■ PLAYTIME!

Working with children can be a lot of fun. Marc Weisberg says, "What I love the most about children's portraiture is that it is a wide-open genre. I truly en- joy photographing and working with children, and I feel it keeps me young in spirit."

One image that parents love is a tight crop of the face. Come in very close, cropping the top of the head, but try not to crop the chin. I like to use a very shallow depth of field. For this image, I used an AF Nikkor 85mm f/1.4 D lens on my Nikon D2x.

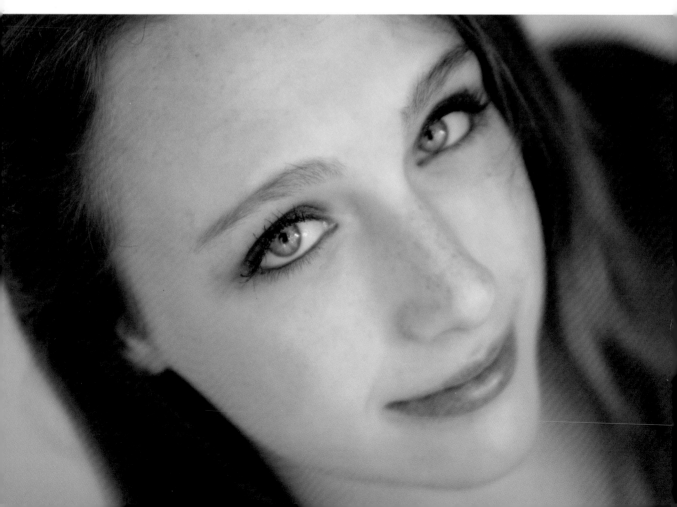

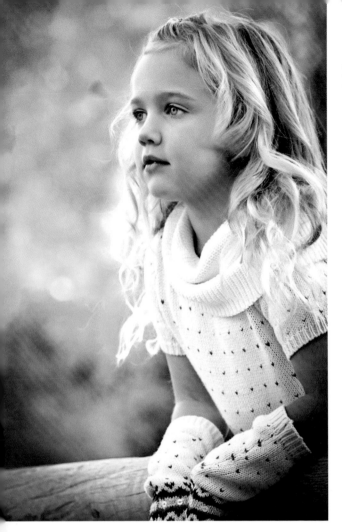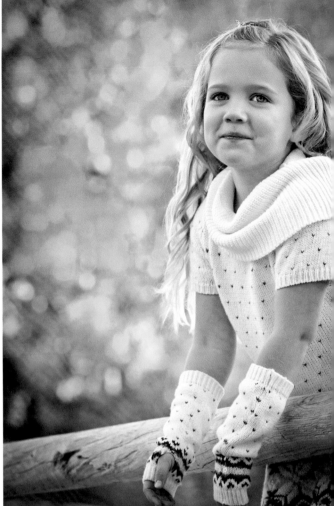

Subtle posing variations can yield additional sales opportunities. Photos by Marc Weisberg.

deliver the finished product, your client should have a rewarding, positive, and memorable experience. My favorite saying is "It's all about the experience." While I have achieved a high level of expertise in technical lighting and digital manipulation, I think what makes me most successful is my relationship with my clients and the experience they have when I'm photographing them.

I recently photographed a family in England. I had been warned that family tension was high and that several family members were reluctant to have the photos taken. Given that the family had flown me to England for the session, I felt tremendous pressure to create memorable images. Anticipating that I was coming into a difficult situation, I put on my game face. Before I even met the family, I knew what I was going to do to soothe and calm the subjects.

I had arranged to meet with the family in a casual environment on the day before the session. At the meeting, I introduced myself

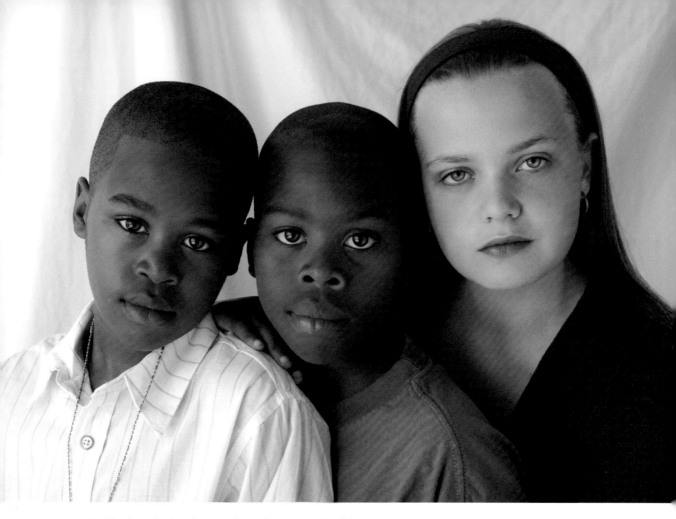

and talked with the family about how wonderful it was to meet them and how much I was looking forward to their session. When I was introduced to the parents, I remarked about how attractive their children were and how excited I was to photograph them.

I went on to ask the clients what they thought they should wear for the photos. By seeking their input, the family became helpful, not reluctant.

On the appointment day, most of the family members arrived early and couldn't wait to have their photos taken. The father in this group was a stern, businesslike man. After the session, he came up to me and thanked me for one of the most pleasurable experiences the family has ever had. That is when I knew that I would be successful in selling the images to them.

Always remember that laying the foundation for a positive experience goes a long way toward ensuring a rewarding session.

ABOVE—One benefit to natural window light is how beautiful the eyes appear. Here, the light from a large window to the right of the kids wrapped around them and illuminated their skin and features. A reflector placed to the subjects' left provided fill. The image was captured with a Nikon D2x and a Tamron 17–50mm lens set at 38mm. The exposure was f/5.6 and $\frac{1}{100}$ second at ISO 400.
FACING PAGE—Window light beautifully illuminates the face and eyes of a child. Here, the subject faced the window. A dark background to her right helped create a defining shadow along her cheek. The low light level allowed me to shoot at f/2.8, which resulted in a blurred background.

THE BEST STAGES TO CAPTURE

There is no one best age to photograph children. Sure, professional photography organizations have recommendations for when it's best to photograph children based on the assumption that they'll be hitting important milestones, but children don't always hit developmental milestones when they are "supposed to." Everyone is different. Also, parents sometimes forget to bring their kids in to document those milestones.

I like to recommend products based upon the child's age. I'll have them come in for a baby book during the child's first year, another album at age 5, another book at the preteen point (12 or 13), an album at 16, and finally, a book when the teen graduates from high school. These stages make sense to me.

I keep samples of these books in my bag so I can share them with my clients and get them thinking about future sessions. Most of my clients come to me every year, and I don't have to offer special incentives to get them to book sessions. Showing the books to prospective or first-time clients, however, can give them a reason to book a session, now and in the future.

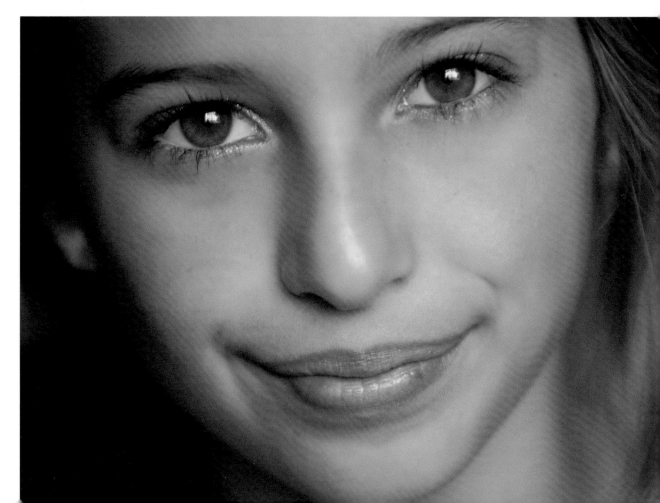

A PRO'S VIEW
JUDY HOST

It is such an honor to do what I do every day. I feel blessed to have a clientele made up of people I've been photographing since they were 3 months old. My oldest is now 19 and off to college. I've never had children of my own, so to have everyone else's is pure joy. I need to make that very clear before I start into my "How to Build a Business" lecture.

I started my photography business almost 20 years ago. I knocked on my neighbor's door and asked if I could photograph her daughter, who was 6 years old at the time. After the session, I entered one of the images in my local photographer's association competition and was lucky enough to win an award. I then made a large wall portrait from it, a 20x30-inch print on canvas, and presented it to my neighbor, along with the award. From then on, word of mouth helped create a business base for me. I have always had a boutique business model. My mission was to

LEFT—This image of Macy was created during one of my workshops. The weather outside was awful, so we brought our backdrops inside and placed them next to a window. Being a natural light photographer sometimes has its challenging moments, so flexibility is very important. Using the window light as my "softbox," I had one of the other students make faces at Macy to get her attention and coax a natural smile. It also helped to distract her from the other students trying to photograph her. The image was made with a 70–200mm f/4.0 lens at 135mm. The exposure was $^1/_{125}$ second at f/4.0 and ISO 1250. RIGHT—Here, my subject was about 14 months old. She had just started to stand on her own and wanted to be everywhere except where I wanted her. Luckily, her father sat behind her and held onto her dress. I used a 24–105mm f/4.0 lens at 65mm. The exposure was $^1/_{125}$ at f/4.5 and ISO 320.

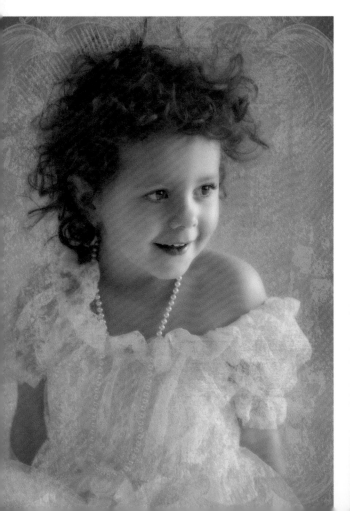

Zoe was 20 months old when this image was made, and she was able to run everywhere. At this age, it's important to give your subject a reason to be wherever they are. Whether it's a game of hide and seek or some music playing, any distraction will be a good one. For this session, I chose a location that would allow for movement so that I didn't need to keep changing my settings. I had beautiful light with the large trees providing some shade, so I let Zoe run anywhere she wanted. Her mother hid behind the trees and played games with her. This image was made with a 70–200mm f/4.0 lens at 70mm. The exposure was $1/_{250}$ second at f/4.0 and ISO 320. All photos by Judy Host.

create a business where I could give my clients the service they so desperately wanted and needed along with a talent and passion for the work. Truly, the secret to success is service. The only difference between me and another talented photographer is the service I provide to my clients. Never underestimate the power of kindness and attention.

I also wanted to create an environment where I could do less work for more money. I run my business almost completely alone. In order to provide the kind of service I'm talking about, you need time to do it. So fewer clients, but higher prices for the work, was the model.

Next, you need to find a must-have product. I was photographing babies, so I designed a baby program. I bought a list of addresses of women who had recently had a child and sent out about 70 invitations a month. The response rate was a little more than 1 percent. The package was a 3-for-1—3 sessions for the price of 1. Paid in advance, the new mom could decide when she wanted her child photographed. Most of my clients would have their children photographed 3 times a year. Others would wait a year or two. After working the program for 2 years, 60 percent of my business was tied to the baby program.

My prices were increased 15 to 20 percent a year. If you were a baby program client, your prices were locked in until you completed the 3 sessions. At that time, if you wanted to purchase 3 more sessions, you could do so at the new price.

The beauty of the model was twofold. First, it kept my clients coming back to me because they had already paid for the session in advance. Second, I was able to develop real relationships with them, and that kept them loyal to me. I can't even begin to express how wonderful it is to become Aunt Judy or the Picture Lady to these little people. To watch them grow up means more to me than any award I could win.

In today's business world, I believe what's old is new. Business is business, no matter what year it is. In order to stay in business, you need to make a profit. Having a good business plan is key. Knowing what your products cost and what your margins are is still the best way to manage your business. I mentor a lot of young people who have a passion for the field of photography, and I always encourage them to follow their dreams. Life is short; do what you love. It will always work out in the end, and if it isn't working out, it isn't the end.

3. PRESCHOOL

A FUN SESSION

When it comes to photographing young children, creating a pleasant session experience is critical. A child should have fun during the session and must be able to connect with you. Without a connection, you won't be able to create images that capture who they really are.

I have a confession to make. In the beginning of my career, I was terrible with children. I had one of those defining moments when I realized I needed to change my approach toward kids. Of course, this happened with my own children. You see, every

FACING PAGE AND BELOW—Using a white seamless background gave this active kid lots of room to move and express himself. As a result, the images show a lot of personality.

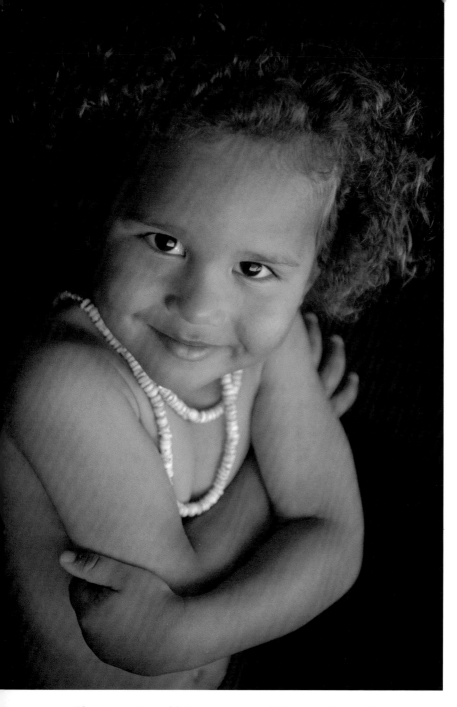

LEFT—Natural light makes working with a preschooler much easier. Besides having a large light source for the child to move around in, you don't have to worry about dangerous lights or equipment. In this studio shot, natural light illuminated the subject from the left. I shot from an overhead angle with a 17–50mm Tamron lens opened up to f/2.8. **BELOW**—Capturing the bond between Mom and Baby is a good idea when working with very young children who have no desire to leave their Mom's side.

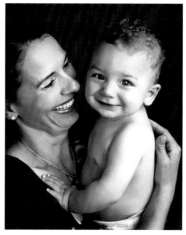

Christmas, I would dress my poor children up in terrible costumes and create a special scene for my Christmas cards. It was fairly easy when they were babies. When they became preschoolers, it was a nightmare.

One particular shoot stands out in my mind. I had dressed my kids as shepherds and a lamb and wanted them to appear to be posed on a hill looking at a star. Of course, very young children

A wide aperture and tight composition draw attention to this little girl's stunning blue eyes. Photo by Marc Weisberg.

want nothing to do with dressing up in something you want them to wear. I lost my temper, but later realized that my expectations were unrealistic. (Incidentally, the image turned out great, but the "session"—well, it just wasn't enjoyable.)

Understanding what didn't work when photographing my own kids helped me to learn how to better work with other kids. Early on in my career, a seasoned photographer told me that when a new client would call to schedule a session for a 2 or 3 year old, he'd *not* book the session. The photographer went on to say that it was impossible to get kids in that age group to stop, sit, listen, and follow directions.

The "terrible twos" phase is an important developmental stage for children. Children from about 18 months to 3½ years old are trying to become independent and establish their own identity. In order for this to happen, they need to make many decisions for themselves and have some autonomy. The downside of their becoming independent is that they are unlikely to follow directions from an adult. So what do you do?

You can look to experienced photographers for ideas about what works to ease the pressures of working with kids in this age group.

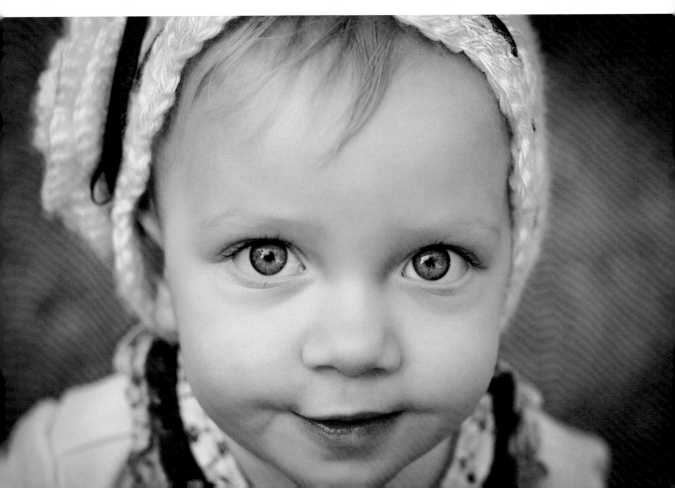

You might find some of the things that work for us will help you too, but honestly, you'll need to figure out what works for you. One thing is for sure: you'll need to be realistic about what young children can do. Some kids may cling to Mom or Dad and will not sit independently to have their photo taken. In this situation, I don't force the child away from her parents. I have the parent sit in the location where I want to take the photo, with the child in their lap (or cuddled up in some way), and I gradually have the child move off of the parent by offering toys or treats. (I ask parents to bring toys and/or treats that are appropriate for their kids to the session.) If this doesn't work, I will have the parent hold the child, and I will take interactive, emotional-based photos of the parent and child together. Sometimes, I can even photograph the child's head and shoulders so that the parent does not show in the image.

A New Approach, a New Product. Early on in my career, I struggled with photographing toddlers and preschoolers. On one occasion, I had a client who wanted her twin 2-year-old girls photographed at her home. Within moments, it was obvious to me that this would be an impossible endeavor. The girls wanted nothing to do with me photographing them. They ran from me, they hid—they did everything in their power to keep me from getting

The "A Day in the Life" concept was born of necessity, but now it is one of the most popular sessions/books that I offer.

■ CHILD DEVELOPMENT

If you're serious about becoming a child portrait photographer, you will need to know basic child developmental stages. For the hobbyist, it is not as critical, but having a few tricks up your sleeve will definitely help. In later chapters, I'll offer some insight into what to expect when working with kids at different ages and stages.

A few families have contracted me to photograph their children every year until the youngest is 18 years old.

near them. I began to feel that I should give up on the session. The mom and I sat on the back patio of the family's home and were talking about the situation when the two little ones started to play in a small wading pool. Within minutes, both girls had undressed and were laughing and squealing in delight as they played in the wading pool. The mother took out a jar of bubbles and started blowing them over the girls as they played in the pool. I seized the moment and started snapping photos. What we got from that serendipitous moment was a wonderful collection of photos of the girls playing and laughing and interacting with their environment. The girls' mother took all of the prints that she ordered and placed them in a small album. This session led to the birth of my lifestyle sessions and the "A Day in the Life" books, and they are now one of my best-loved sessions/products. I currently have a few families that have contracted me to photograph their children every year until the youngest is 18 years old. This type of commitment is a wonderful thing for a portrait photographer.

THE PARENTS' BEHAVIOR DICTATES THE SESSION

If the parents are stressed out about the session, chances are, the kids will act up. For the best-possible session results, therefore, I highly recommend that you take a relaxed, casual approach anytime you are photographing preschoolers.

I have found that working in the home is the least stressful photographic approach for young children and their parents. At home, everything is comfortable and familiar for the child, and that familiarity can be reassuring. If the parent wants a classic portrait, I can easily bring a backdrop with me. I always allow extra time for sessions conducted in the clients' home in case the family isn't ready when I arrive, or in case the photography takes longer than usual.

In my conversation with the parent, either on the phone or during a face-to-face consultation, I emphasize that the session will be a fun experience, not a stressful one. I tell them there will be no need to worry or rush, and that they should relax and take their time in getting the child/children ready. When I arrive at the home, most families are not ready, and I use this to my advantage. I take some time to find the best light in the home and determine

A relaxed parent makes for a more comfortable, session-ready toddler or child.

A PRO'S VIEW
MIKE STRICKLAND

I've been thinking about how we, as photographers, are as much psychologists or even anthropologists as we are artists. For me, it's important to quickly get a feel for the family dynamics and the interplay between family members.

I recently had a family portrait session in which the main subject was an 18-month-old girl. The parents and grandparents were also to be photographed. As is the case with all young families, the baby was the center of their world. She was used to having her photo taken at home, of course, but not at the resort where they were staying, and I was a total stranger to her, not her usual photographer.

The little girl didn't want to cooperate, so I used my 70–200mm f/2.8 lens and found a spot to shoot unobtrusively. I gave the parents directions for the placement of the girl and themselves so I could use the light to my advantage and get the expressions I wanted. Working this way takes longer, but it reaps great rewards for you and the family.

Over the years, I've learned that having more patience is the key to success. Over a century ago, Edmund Burke said something that applies to child photography: "Our patience will achieve more than our force." If we sit back and let the moments happen—become a family and child photographer and photojournalist, we will create greater, longer-lasting memories for our clients, and we will build a relationship with our clients that can last for years.

Some kids can be a bit shy about "performing" for the camera. It can be a good idea to take a photojournalistic approach in those cases. Consider using a long lens so that you can work unobtusively, and when you're presented with a photo-worthy expression or action, press the shutter button and capture the shot. Photos by Mike Strickland.

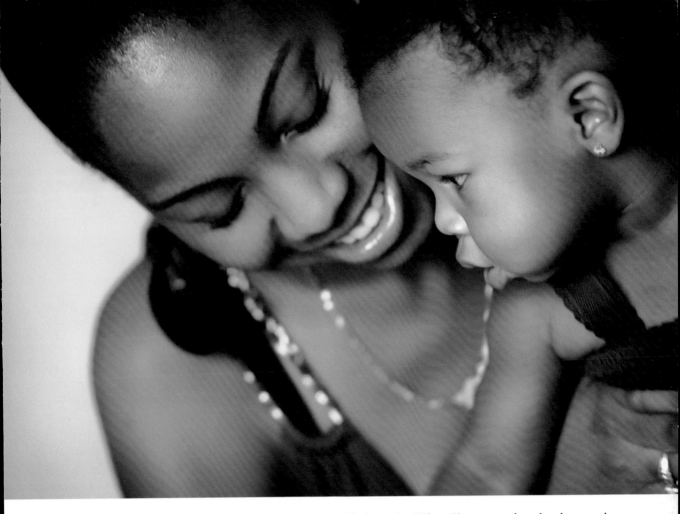

When it comes to wiggly pre-schoolers, one of the only things you can do is seat the child in a parent's lap. Take this opportunity to capture interactive moments.

which locations I will shoot in. When I'm greeted at the door and a parent tells me they're not quite ready, I say, "Don't worry. I'm glad you're not ready. I can use a little more time to set up." This relaxes the clients. In some cases, the family *is* ready when I arrive. In that case, I ask family members and even the little ones to help me with my props and equipment. Simply having them bring things into the house or into another room while I am looking for the best light gets them involved in the process and helps them relax.

I ask the parents not to have high expectations for the way the children should behave, and I suggest that they not worry about discipline. I tell my clients that the session is meant to be a fun activity, so there's no need to worry if the child is not acting perfectly. I do recommend that they set up a reward system for good behavior. Sometimes simply telling a child that they can participate in a special activity or have a special treat once the session is finished

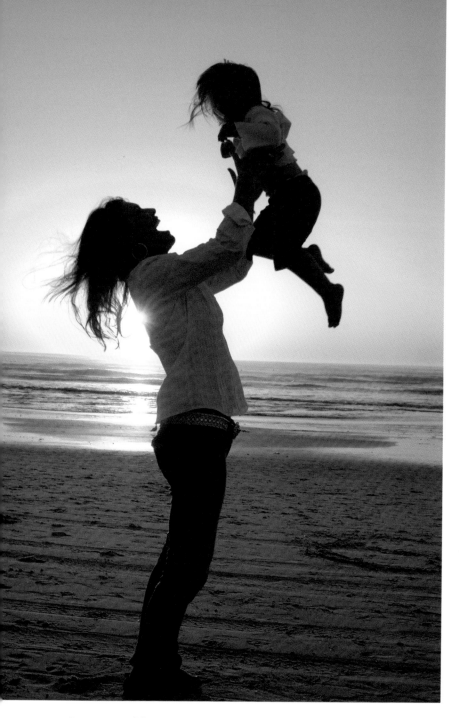

Parents love real moments. When I go to a location with a family, they will ask where I want them to pose. They expect to sit, smile, and look at the camera. I do capture a classic posed image, then I tell them to have fun, relax, and enjoy the moment—and I capture some candid shots.

Check with parents to be sure the child has no food allergies and is not diabetic.

is a powerful incentive. But for younger children I recommend the parent bring small snacks or treats, and I give them treats for good behavior while I'm taking the photos. (I also keep my own supply of treats on hand. If you decide to take this approach, check with parents to be sure the child has no food allergies and is not diabetic.) I find that when I am the one giving the treats, the child

1. Book the appointment at the time of the day when the child seems to be at his or her best. To be a successful child portrait photographer, you must be flexible about session times.

2. Do not come on strong when you first approach the child.

3. Use a high, soft voice when talking to the preschooler.

4. Get down on the child's level when you greet him.

5. Tell the child immediately what fun you two are going to have.

6. If the child is fussy, let the parent hold her until she is comfortable with you.

7. Start the session by allowing the child to play.

8. Be playful with the child—play peek-a-boo or other games to get the toddler to interact with you.

will behave for me and follow my directions. I ask the parents to avoid giving the child verbal or physical prompts, as I want the child to follow my directions during the session.

HELPFUL APPROACHES

Give the Child a Job. Preschoolers like to be helpers. One way to get them to follow your direction is to have them "help" you with the session. I often give the young subject a plastic camera to hold. Sometimes, I have them press the button on my light meter. Be careful, though: if you let a kid hold your equipment, you might not get it back!

"A Day in the Life" Sessions. "A Day in the Life" sessions work really well with this age group. As a parent, I've realized that some of my most precious memories were made when I did the simplest things with my children—feeding them, bathing them, playing with them, etc. When planning for a session, you might suggest that parents stick to their daily routine and allow you to capture those moments. While observing the family's routine, you should also be able to capture a few great shots. If you find you are not getting portrait-quality images, set up a chair or a blanket near a window that provides great light. Once the child has warmed up to you, have the parent and child go to that area and capture a portrait.

Show and Tell. Another way to engage a preschooler is to have them show you their favorite toys. Depending on your goals for the images, you might consider allowing the child to hold on to that toy while you're creating the images. Sometimes keeping toys or objects on hand that resemble photo equipment can be helpful. Introducing this object can help you to get the child's attention. Additionally, such an object will likely be black and will not compete with the child's face in the photo.

Treats. If I'm using a backdrop, I often place the snacks or treats brought in by the parent or supplied by me into the folds of the backdrop on the ground. Once the child is shown that there are treats hiding in the background, he will sit there and try to spot the treats. This method works well as long as the treats are very small and are not chocolate. I place about 3 treats. It's important to limit the number of treats that are offered. You need to use

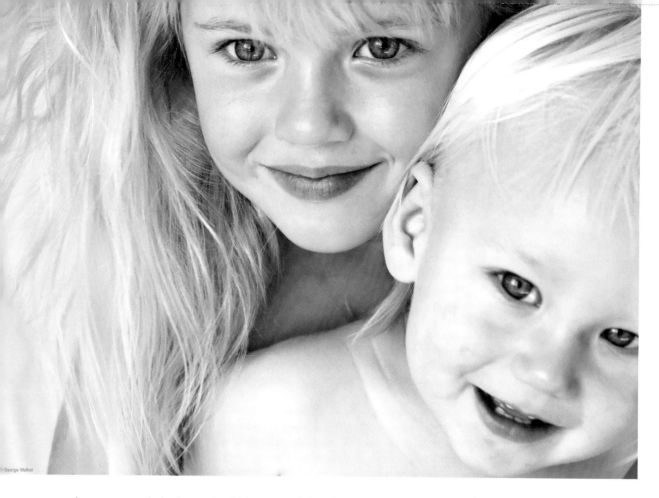

the treats to help keep the kid engaged for the duration of the session.

Puppets and Toys. For years, photographers have used puppets and toys to get children's attention. The truth is, it *does* work. For the younger child, I use a finger puppet, but I have found that just my finger works well if I pretend it's a buzzing bee. I will tell them "Smile or Mr. Bumble Bee will come tickle you." Make sure you ask the parent if it is all right to touch the child. (One of the first things I tell my clients on the day of the session is that I will be touching them to move hair or distractions and to pose them.) If you're having a problem getting a positive expression from a child, the little busy bee technique may help. The drawback to using the buzzing bee is that you have to work very quickly. I tell the child that the buzzing bee is coming, and I reach over to tickle her under the chin or on the belly. I have to get back to my camera and press the shutter button while she has that positive expression on her face. If you find it difficult to capture that expression, try

A favorite way to create fun images of kids is to set up a light background with a direct light source on the subject. I then have the kids wear light clothing and use a fan to blow their hair around wildly while they play and laugh. The parents love the carefree and spontaneous look of the images.

placing your camera on a tripod, use whatever technique works for making the subject smile, and use a remote shutter release to capture the image. If you have a problem with the child reaching for the puppet (i.e., toward you), try giving her the little finger puppet and tell her to hide it on her tummy. The puppet is small enough not to show up, and the child will usually giggle when she places the bee on her tummy.

Be a Kid. Terri Rippee, owner of Rippee Photography in San Diego, CA, says that she is a big goofball with the children and plays with them. "If they are old enough, I ask them if they can see that chipmunk in my camera who helps me—and say hi," says Rippee. Kim Treffinger likes to put the children she's working with at ease, even if she feels silly, by offering to tickle Mom or Dad. She finds the children love it. Finally, Kay Eskridge, owner of Images by Kay & Co. in Arizona, says, "I know no humiliation when it comes to photographing a child."

THINGS TO AVOID

Steer Clear of the Emergency Room. You are fortunate to be able to learn from other photographers' mistakes. I've made plenty in my career. One stands out.

> You are fortunate to be able to learn from other photographers' mistakes.

Using the parents as props keeps the viewer's eye on the young subject while keeping the child stationary—and safe.

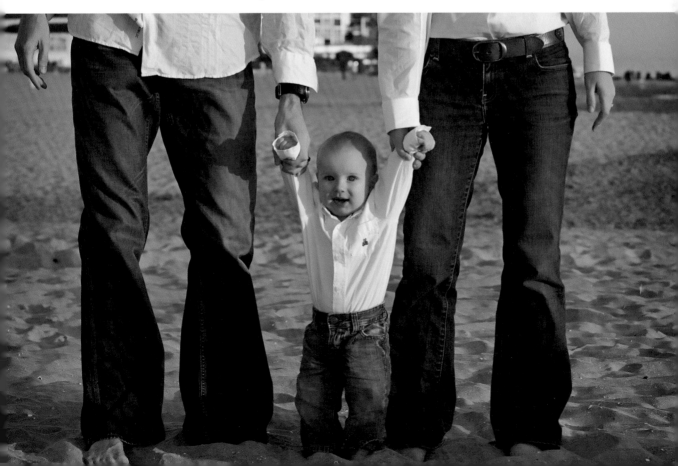

Early on in my career, I took many workshops from other photographers. At one workshop, the photographer said she purchased small, pretty stones to give to children as gifts once they finished the session. She called these little stones "pixie stones" and said they held a special kind of magic. She said that if the child was good during the session, they could take one home.

I came home from that workshop and immediately bought myself a little bag of pixie stones. I was able to use those little enticements only once. You see, at my first "pixie stones" session, I proudly displayed the stones to a little girl and boy. They selected their special magical stones to take home with them. The clients had come for a family group session, and everyone was dressed up and looked perfect. After they left my session, they were heading out to a special dinner with family and friends.

Well, upon leaving my studio, the little boy promptly swallowed his pixie stones down. The mother later told me that they went from my studio straight to the emergency room, where they spent the evening while the doctors looked for that little stone and waited to see if it would damage the child in any way. Obviously, I no longer use pixie stones!

Don't Be a Clown. In the presence of young kids, many adults fall victim to a condition I call the clown syndrome. They talk loudly, use exaggerated expressions, and are too aggressive in trying to interact with the child. My personal experience as a parent has helped me understand how best to approach children. All three of my kids were shy around that type of adult behavior, and it took them some time to warm up when they found themselves in new surroundings. The last thing they would want is to have an adult approaching them in a very loud and boisterous manner and forcing them to interact. What did work for my kids, and now works for me in my career, was a calm, quiet voice—a voice that was positive and happy. If you use a soft voice and relaxed mannerisms and don't require kids to interact with you beyond greeting them and telling them how much fun you're going to have, they'll warm up to you rapidly. Once I have greeted the child, I go back to interacting with the parent. This allows the child to observe me and become comfortable with my presence before I require anything of them.

My personal experience as a parent has helped me understand how best to approach children.

■ SPONTANEITY

One of the best ways to learn to anticipate memorable moments is to photograph children's parties and sporting events. Previous to doing this, I found it difficult to capture a spontaneous laugh, giggle, or playful smile. The more I practiced in such lively settings and watched the children, the better I was able to predict their actions and expressions.

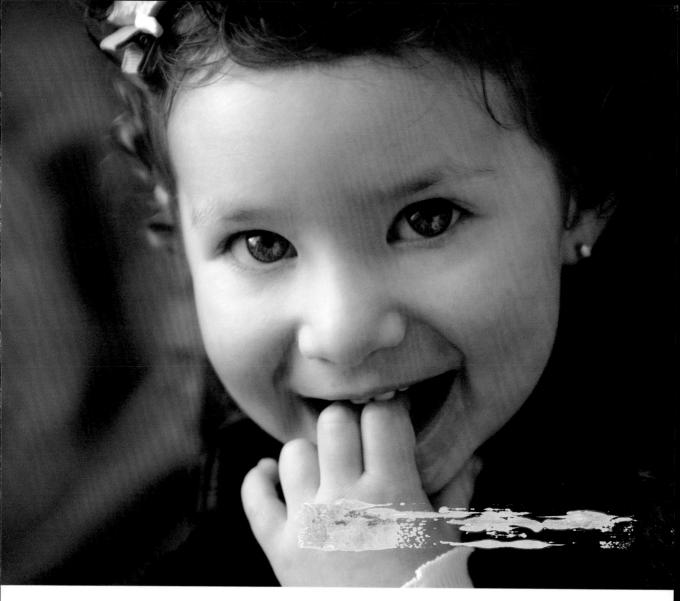

Start slow in a session with a young child. Let the subject warm up to you and the studio environment before you start taking pictures. Being playful but not loud helps. Using a stuffed animal or puppet will allow you to get their attention and build rapport.

Once I am ready to interact with the child, I like to get down to his level without getting too close or requiring that he interact. A few minutes later, I may ask the child to take something or give something to me. This helps to create a connection.

READING THE KID'S PERSONALITY

To become a good child portrait photographer, you will have to learn to read the child's personality quickly. This approach isn't reserved for preschool-aged kids, of course. It holds true for children of all ages.

During the consultation with the parent, ask what the child likes and dislikes. Try to gather important information about the kid's

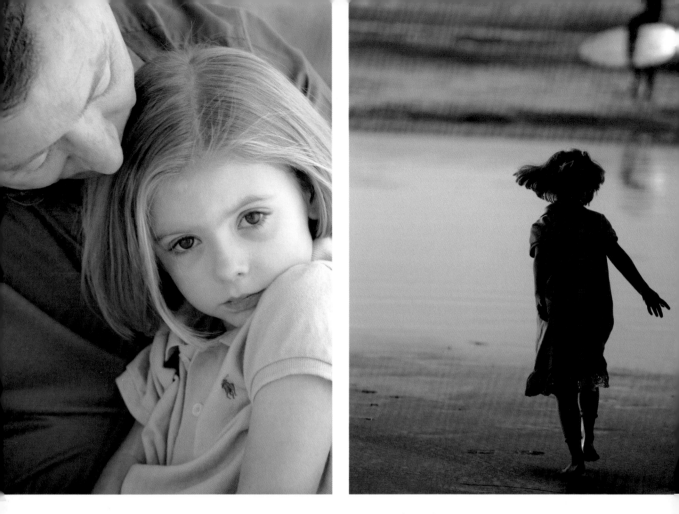

demeanor, personality, and things that they struggle with. Take notes and review them right before the session.

Once you have gauged the personality of the child, modify your behavior to match that child's personality. As a rule of thumb, I've found that many boys age 3 or older are playful and boisterous. Most girls of the same age take a softer, calmer behavioral approach in front of the photographer. Of course, your best bet is not to rely on generalizations, but to learn about the subject.

LEFT—The security this little girl found in her dad's embrace allowed me to capture a natural moment with a storytelling quality that the family will cherish for years to come. RIGHT—On location, a young child will want to play, not pose. Offer to let him run and play once you are done. Tell him you are going to take only 10 photos, and then it will be playtime. Capture 10 shots for every one that you count off, all the while encouraging the subject and getting him to participate to help the time speed by. When he runs off, you can capture some unposed, real moments.

If you have trouble being around kids and talking to them, you should not be a child photographer. I totally relate to kids. I love kids. I've also found that you need to disarm the parents. Without disarming the parents, you won't get the kids. The parents will jump up and down and act a fool behind you. I politely tell them to have a seat and to let me do it. I tell them that the child is in a strange place, and this will only overwhelm the child. I simply let the child explore the space and don't say a word.

After a few minutes, I ask the child to hold something for me. It doesn't matter what it is as long as they take it. It distracts them and stops the fear. Next, I ask for it back and have them take a seat. I never bring my camera up until I know the child, meaning he or she is responsive to me as a person, not as a photographer. When I feel they are ready and comfortable in the space, I take a few shots and then stop. That's when I bring Mom over and actually have the child take a quick shot of Mom. This gets the kid laughing and makes them feel comfortable with me. (Photo by Jason Romero.)

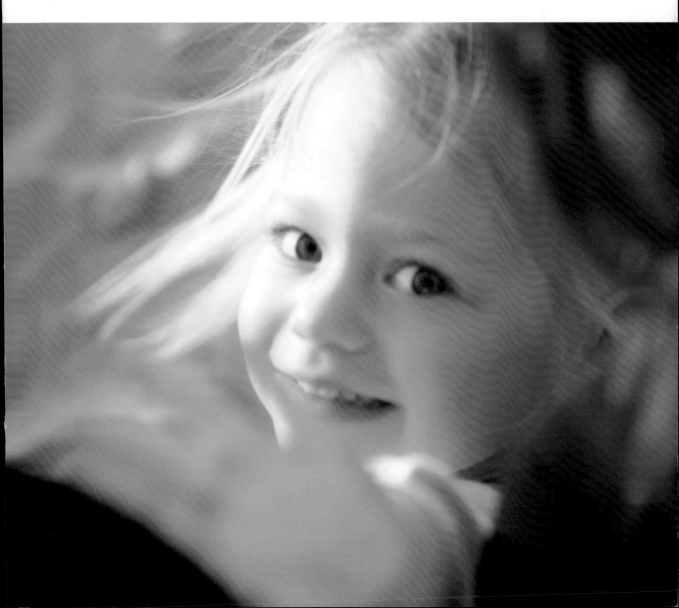

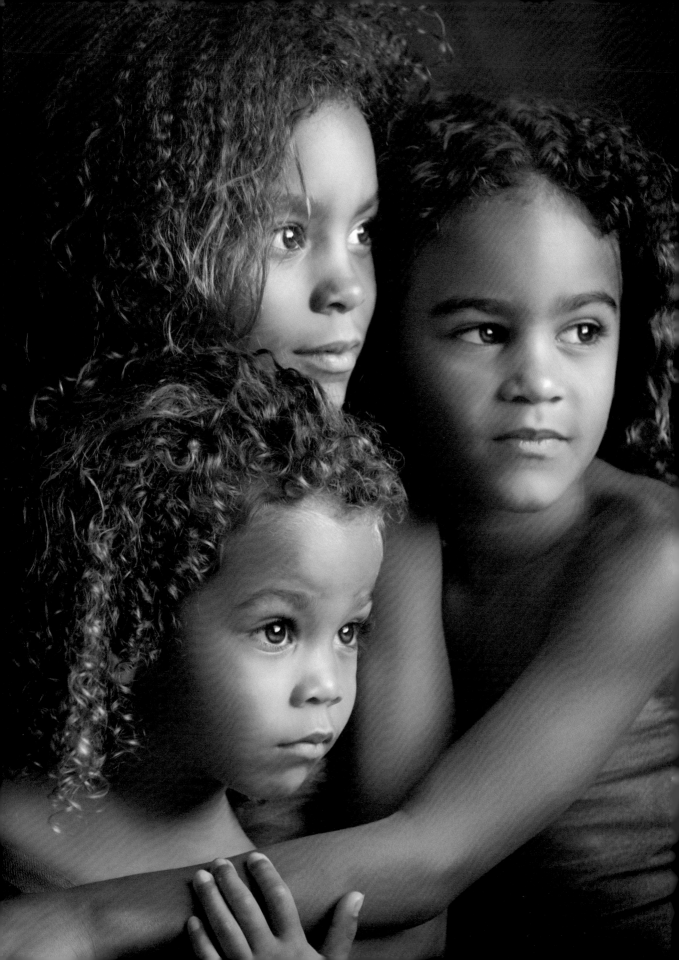

4. GRADE SCHOOL

FACING PAGE—For this portrait of three sisters, the light came from an open garage door that was diffused with a white sheet. With a high light ratio (over 3:1), I had them turn their profiles toward the light, letting the sunlight fall on their faces. BELOW—This older grade-school girl came into the studio for a family session. Once I was able to work with her alone, we came up with some artistic images that went beyond a typical portrait approach.

"ART"-STYLED PORTRAITS

Every photographer has favorite ages and stages to photograph. I love working with grade-school kids—those in grades 1 through 6. At this stage, most children seem eager to please adults (that may be why this is my favorite age group).

Grade-school kids may already be conscious of how they physically appear to others. They *do* want to look good in photos, but they aren't yet hypersensitive about their looks like teenagers are. This makes it possible to capture amazing, artful photos, such as a close-up of the face with a shallow depth of field or pictures of the child laughing, playing, or wearing creative clothing.

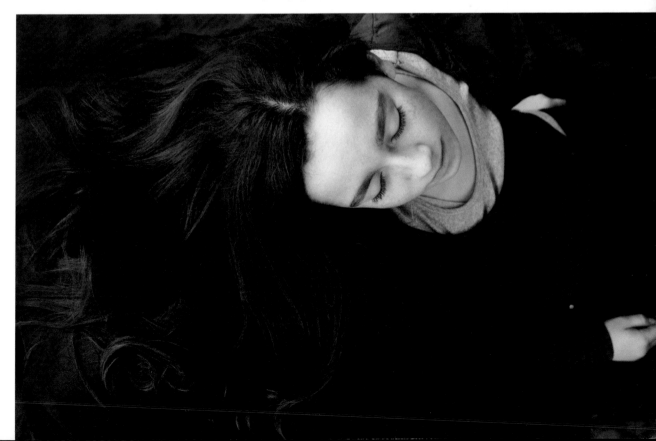

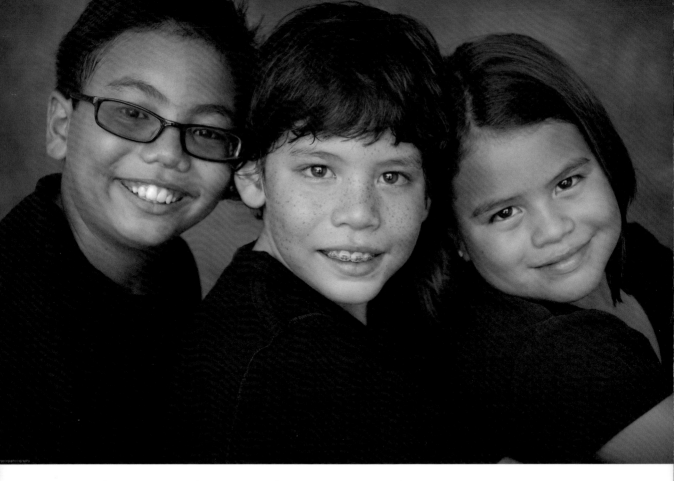

When working with grade-school kids, it can be a good idea to ask for their help in posing them. You can also ask them to help you select photo locations. They love to help and to be asked for their opinion.

" A DAY IN THE LIFE" SESSIONS

My "A Day in the Life" sessions are really popular with parents whose children fall into this age group. The reason is simple: their lives revolve around the children's school and extracurricular activities. Kids of this age still want to please their parents, and they enjoy being watched during sporting events or other productions. Keep this in mind when consulting with the parent about these sessions. Have them bring sporting or dance gear along for the shoot. You may not be able to fill a whole book with these shots, but it's always a great idea to get a series of images of the children enjoying their favorite activities.

ABOVE—For families that I photograph every year, I try to do this type of photo each time. I line the kids up by age and photograph them with their faces close together. Over the years, the parents appreciate seeing the changes in and growth of the kids. **FACING PAGE**—When out on location with a family, I always make sure to photograph each of the children alone. A key to having multiple images to sell is to take several different poses of each child, then repeat the posing series with each kid. This way, you can sell the parents a series of matching prints of the kids.

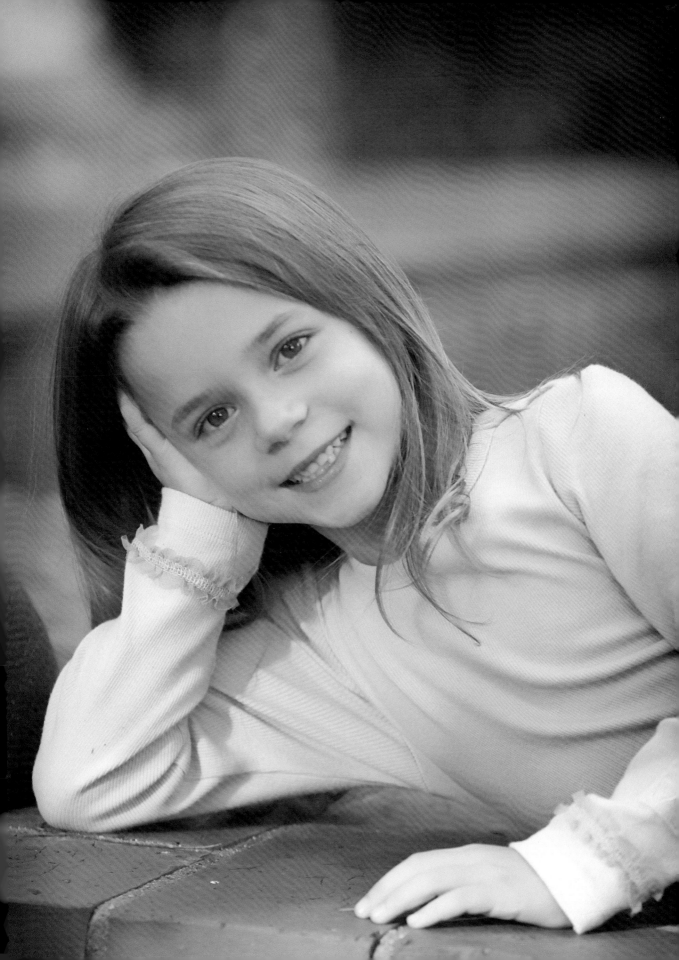

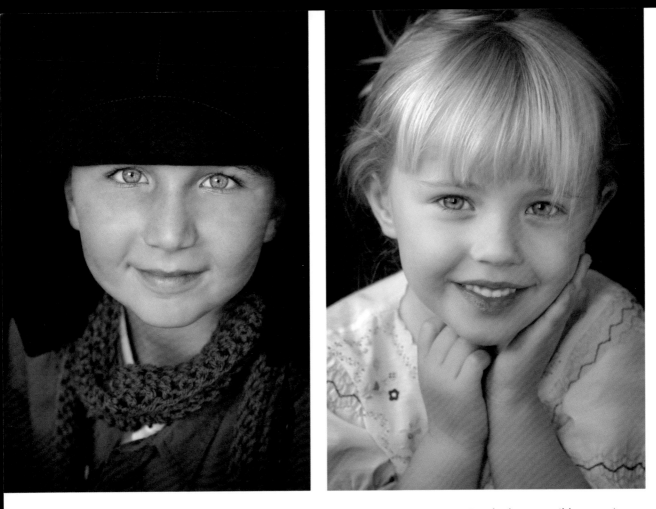

CHALLENGES

One of the problems you may encounter when working with fe-males in this age group is that the older girls may try to have you capture images that are too mature for them. With the media and the Internet always exposing kids to mature subjects, many want to look older than they are.

I had a situation in which a girl who was about 11 years old arrived for the session wearing mascara. The parents didn't say a word about it, so I let it go. When it came time for reviewing the props, the parents noticed. I've since made it a point to bring up the issue of makeup and nail polish during the consultation.

Some of the kids—particularly the boys—in this age group can be rambunctious, and it can be a challenge to get and hold their attention. Small rewards help. For the younger grade-school kids, getting them to help (e.g., straighten a backdrop, hold onto clamps or other equipment) can also help ensure their attention is on the session.

For the best-possible portraits, get your young clients invested in the session. Consider asking for their help with little tasks; you'll make them feel helpful, and this can raise their confidence.

5. MIDDLE SCHOOL

WHY THESE KIDS WILL STEAL YOUR HEART

Middle school is a difficult time in a child's life. I find kids in this age group to be very vulnerable. If you can create a positive bond with a subject in this stage and make her feel comfortable, though, you can create some breathtaking images.

More than anything else, middle school kids want to be liked. I recommend that you compliment the subject on something you notice that is unusual or attractive about her when you first meet. Sometimes I start with her choice of clothing.

Kids this age can be a little self-conscious. If the subject has gorgeous eyes or great hair—or perhaps a stylish outfit—mention it, and be sure to play up that asset on-camera.

All parents love to see a smile on their child's face. For the middle-school kid, you may have to be silly, make jokes, or get the parents involved to achieve that happy, smiling look. For this image, the girl's parents helped elicit a great expression. I used a 70–200mm f/4.0 Tamron lens at 150mm with my Nikon D2x to get this shot. With this lens, I have to be a few feet away from the subject.

Kids in this age are eager to be heard. Ask the middle-schooler to help you with posing ideas, and ask their opinion about great shoot locations.

If your subject seems to be self-confident, tell her you'd like to take some images like those found in a model's portfolio. A pre-teen would love to look like a model, and if you can make her feel like one, she'll never forget the experience.

CLOTHING SELECTION

During the pre-session consultation, parents invariably ask what their child should wear. When it comes to middle-school kids and teens, I ask the parents not to be too worried or controlling about what the kids wear. I give them loose guidelines and ask them to let the kids pick their own clothing. If the parents really want to take more control, I recommend bringing two outfits—the parents' choice and the kid's choice. I have the child start the session wearing the clothing that the parents prefer, then I explain to the child that once we are finished with the photos Mom wants, we will do some photos for them in their own clothing selection.

■ BOOKS

One of my business's most successful products is a book I create featuring 12- to 13-year-old subjects. I was asked many times to photograph bar and bat mitzvahs, and I thought it would be nice to document this stage of life for all of my clients, regardless of their beliefs—so I began to tell parents that 12 or 13 is an excellent time to capture the inner person that is developing and changing every day. I usually find that it's best to photograph girls at age 12—or possibly even a little sooner—and boys around age 13. What makes these books special is that I also interview the teen and add quotes, verses, and other things that are important to them in the book.

FACING PAGE—Middle school kids love being photographed like models. Start the session with that in mind and tell them you need them to help with the posing. They will be eager to participate. This subject brought several accessories along for her beach session, and we used them to create a series of striking looks.

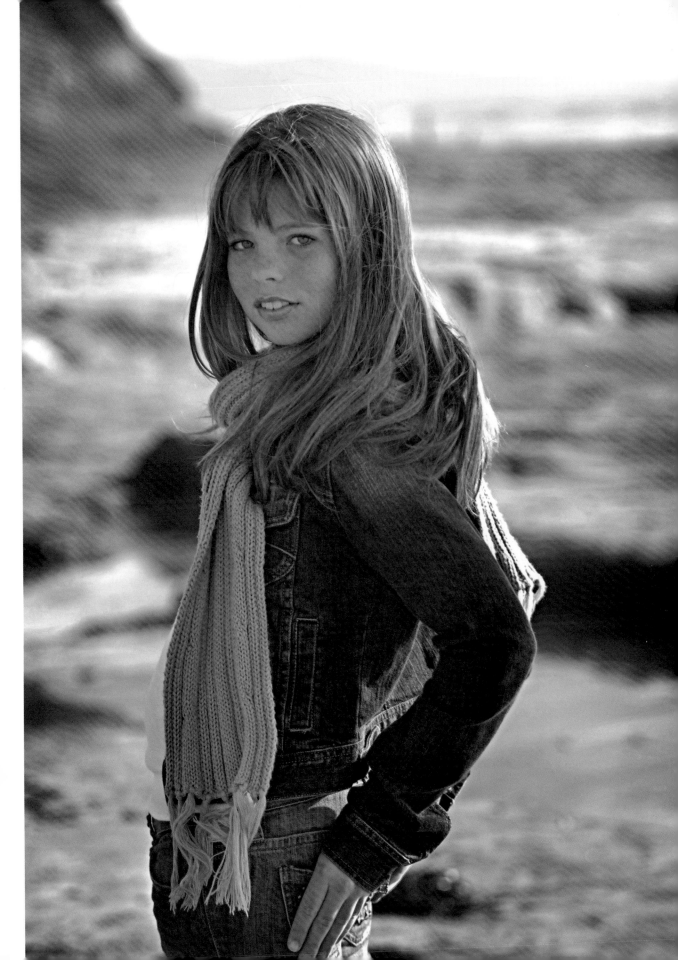

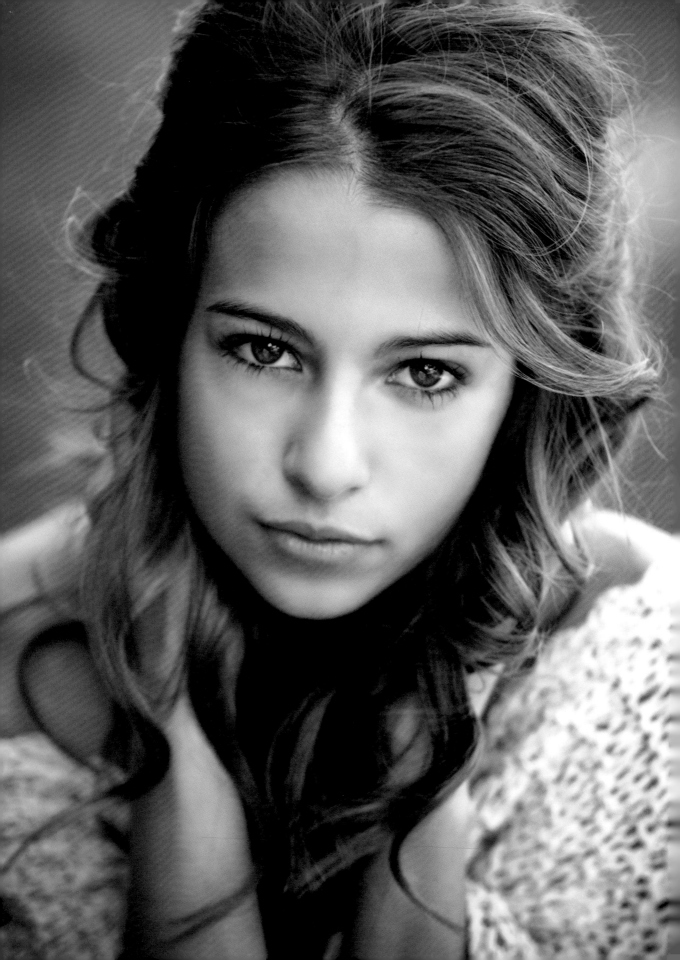

6. HIGH SCHOOL

THE EARLY YEARS

Early high-school students are not exactly kids, but at this age, it's a great time to capture the end of childhood. I think many parents feel that the transition from childhood to the teenage years is awkward. However, there's something very precious about that

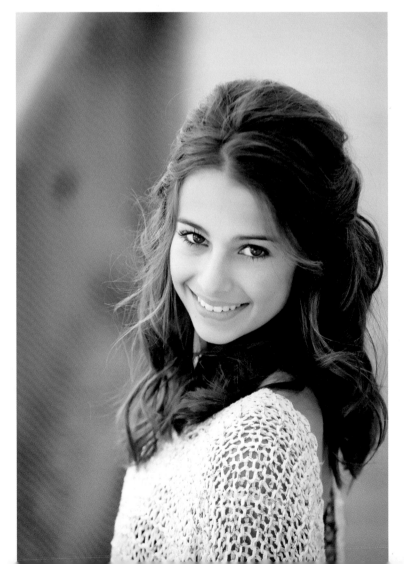

FACING PAGE AND RIGHT—These images were captured in the young high-schooler's yard. Working at the subject's home can help insecure subjects feel a little more confident. As an added plus, she will have access to all of her clothing! Before the shoot, this young lady and I scouted her yard for the most pleasing natural light. These images were shot with my 70–200mm Tamron lens on my Nikon D2x. The lens allowed me to throw the background out and focus so that the viewer would be drawn to her eyes and face. The exposure was $^1/_{320}$ second and f/2.8 at ISO 400.

transition, and I'm fortunate that my clients have allowed me to capture this time in their child's life.

Subjects in this age group are often involved in sports and other extra-curricular activities that help to define who they are. Encourage them to bring sporting equipment, musical instruments,

TOP, BOTTOM, AND FACING PAGE—One way that I sell the idea of a book for a younger teen is to help the parent and teen shop for outfits for the shoot. For this session, I met the subject's mom at a local resale shop. We wanted to find some funky and fashionable clothing. We picked out several pieces that created an outfit or could be added to the teen's wardrobe. I also have a stylist who will meet the parent and/or teen and work on clothing ideas. The stylist charges her own fee.

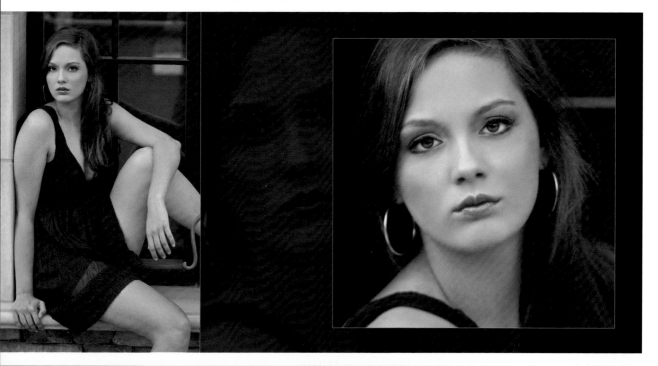

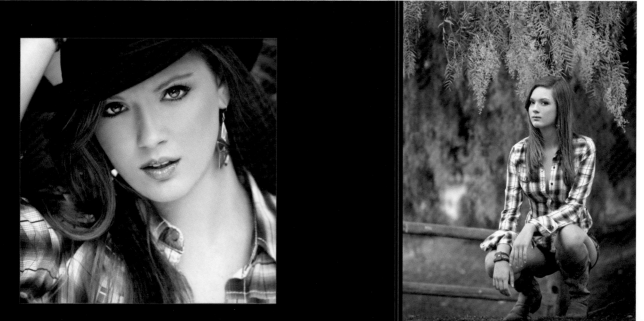

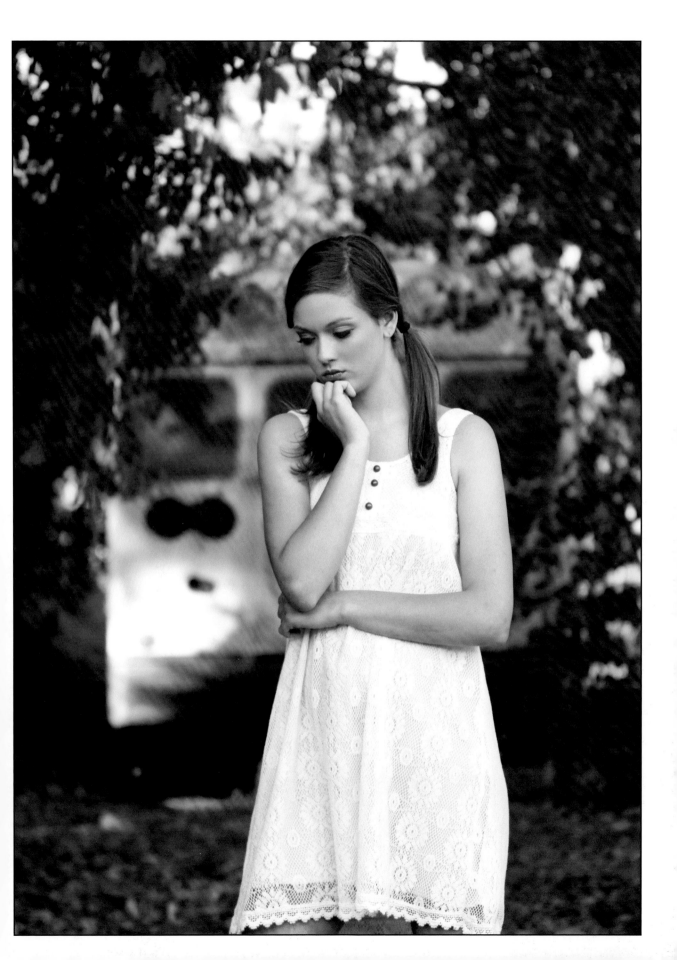

and similar props to the session. These things help to tell a story about the individual, and by allowing/encouraging the teen to bring these items in, you may help to pique his or her interest in the session.

I love working with subjects in this age group. They tend to be much more confident than middle-school kids. They know who they are and where they're going. Here, again, you may want to try to capitalize on that self-confidence and create some model-inspired photographs.

I love working with subjects in this age group. They tend to be much more confident than middle-school kids.

The angle of view that you shoot helps to establish the voice of the image. Move around the subject as you shoot, and the direction of the light changes. Here, I moved from a more standard angle of view to an overhead camera angle. The result was a dramatic image that draws the viewer in.

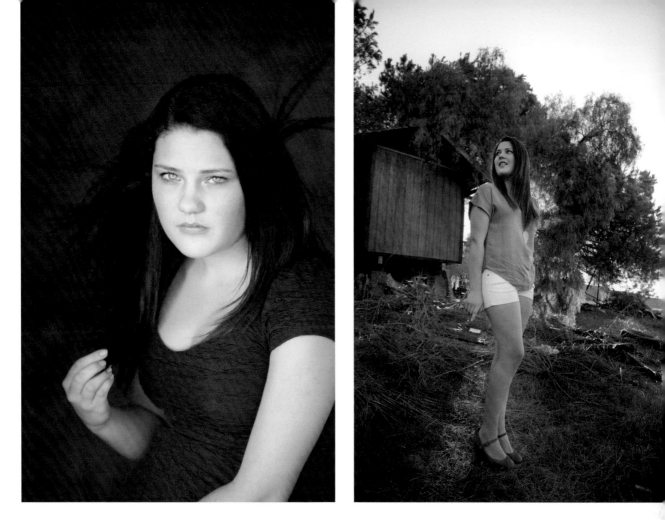

I like to capture an array of portraits indoors and out to create a variety of portrait looks for the teen and parents to choose from.

For me, the best part of photographing subjects in this age group is listening to what they have to say. I love asking them about life, where they want to go, and what they want to do. If you are able to photograph this teen again at graduation, you can ask the same questions. Recording their thoughts and feelings in a keepsake album is something parents cherish.

THE FINAL YEAR

Digital photography has made picture-taking easier for everyone, and it has become particularly popular with the younger generation. Over the last few years, I've seen a dramatic change in the business of high-school senior photography. Not too many years ago, storefront studios were able to make good money photographing seniors, but that is becoming extremely difficult. In southern California, portrait studios still can be contracted by a local high school to capture all of the seniors' classical portraits.

This teen brought his rugby ball and uniform; this allowed me to conceptualize some images that helped tell his story. The natural-light image was made in his garage—all that was required was a backdrop. I faced him toward the doorway and used a reflector on his right side. I find that using an ISO of 400 works well to give me the range of apertures I need while keeping the shutter speed high enough to avoid blur.

However, many teens are opting to have their photographer friend take their portrait instead. Due to this trend, many studio owners have had to change their strategy, incorporate a new style and look, and work very hard to get and keep high-school clients.

The Specialized Senior Portrait Photographer. To compete in this ever-changing market, you will have to offer something that the paying parent appreciates *and* you will need to satisfy the teen's desire for fresh, contemporary images. I have branded myself as a photographer who creates and does things differently from a traditional portrait studio photographer. This branding has opened the door for me to now have my current clients' growing kids as additional sessions and income.

My experience as a family photographer has taught me to anticipate the kinds of images kids begin to want as they

You will need to satisfy the teen's desire for fresh, contemporary images.

High-school seniors want images with movement, emotion, and style. Location work lends itself well to capturing those qualities. For this image, I set the camera to ISO 400 in order to capture movement and keep the subject in focus. The exposure was $^1/_{320}$ second and f/2.8.

If God is all you have, you have all you need.
John 14:8

grow older. Every time I photograph a family session, I do "breakouts"—shots of an individual family member or smaller family groupings. During these breakout sessions, I connect with the teens, ask questions, get their input, and create interesting and dynamic individual portraits of them. In doing so, I have learned a lot about what they are looking for, and I have earned their confidence in my ability to see things their way.

One thing I have learned is that positive reinforcement goes a long way toward connecting with these kids. My previous experience in working with professional models inspired me to coach the teens into fashion-style posing. Young women in particular have appreciated this for their fashion-inspired sessions.

Senior Session Basics. I sometimes begin to communicate with high-school seniors on the phone or via e-mail, but most often, I text. I ask them where they would like to be photographed, what style of image they are looking, and if they have any ideas for the session. Sometimes I also send them examples of work I have done in the past.

Students are often unsure about what to wear for their session. I suggest that they put together four to five outfits with accessories, and I tell them I will help them make their final selections. One reason I like to offer my input is that today's fashion is very

When photographing seniors, I make sure to capture flattering poses. I also want images that show the subject's personality, and shots with special details. A collection of images that meet these guidelines come together beautifully in a final book.

I sometimes communicate with high-school seniors on the phone or via e-mail, but most often, I text.

unflattering for the majority of young women. The loose, unfitted blouse that is popular today creates a large, shapeless silhouette. In reviewing the clothing options, I can help steer the subjects away from unflattering outfits.

For young men, clothing selection is much simpler. I usually have them wear their favorite outfits, and then tell them to bring what their mom wants them to wear. If they're going to do something that has to do with their sports, I give them the option to change out of their favorite outfit and into a sports outfit. In southern California, surfing is a very popular sport. Some sessions are held at the beach. The young man or woman will change into their swimsuit or wet suit, and I will take some images of them along the beach with their surfboard and then in the water. You could use a similar approach in choosing a location that suits football, volleyball, or basketball images.

Session Locations. Most senior sessions begin at the client's home or mine. When I go on location, I like to bring a black backdrop, a white backdrop, and a multi-colored muslin. I choose the background that best suits the subject's coloration and the clothing selection.

I set up a mini natural light studio and take some classic portraits using window light. I sometimes work in a garage, and in that case, the light streams in through the open garage door. During this part of the session, I also photograph the senior with trophies, medals, books, and art. If a female wants to be photographed in a

I like to bring a black backdrop, a white backdrop, and a multi-colored muslin.

To create a standout beach image, I often use Adobe Lightroom's Color Creative preset called Aged Photo; it adds a moody look to the image.

"Twenty years from now you will be more disappointed by the things you didn't do than by the ones you did do. So throw off the bowlines, sail away from the safe harbor, catch the trade winds in your sails. Explore. Dream. Discover."
- Mark Twain

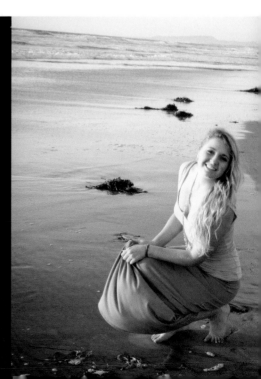

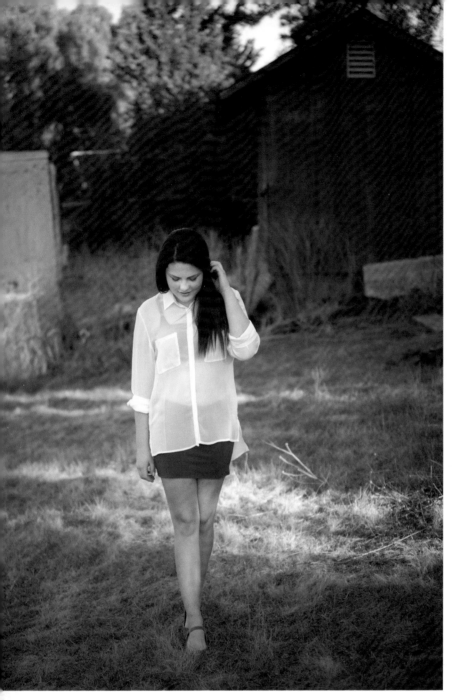

LEFT AND ABOVE—Madison came to my house for the classic-portrait portion of her senior session. When that was complete, we headed out for some location shots. She had brought several outfits to my house, and, before shooting, I went through her selections and we decided which ones would work best. She was a bit shy, so I shot several images in which she wasn't interacting directly with the lens. Those images had a storytelling feeling that she and her family enjoyed.

FACING PAGE—For an unstructured, fun portrait look, I sometimes let teens "play" rather than directing their moves during the session. Allowing the subject to bring a best friend or family member can help you eliminate some of the tension that's inherent in a session. This, too, may help your subject have a little more fun.

formal dress, she does a clothing change and I take those images during this phase of the session too.

Next, I have the student change into the first outfit selection for the location portion of the session. I pack up my gear and we (separately) head to the location.

One of my favorite locations for photographing high-school seniors is a design district; the area has an urban feel and features

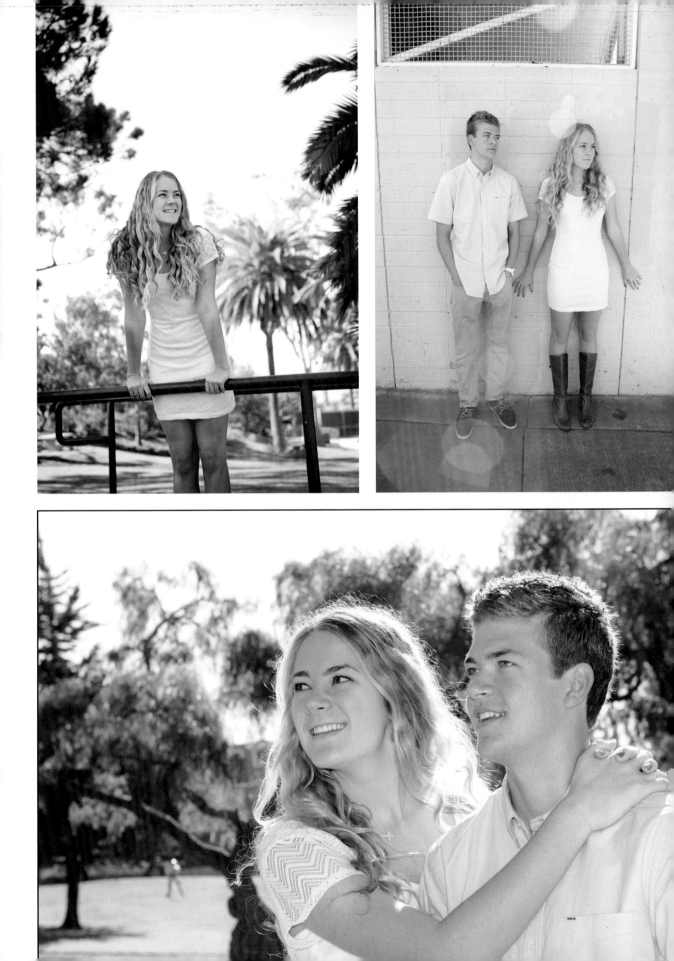

hip warehouses with traditional fixtures. There are many brightly colored walls, unique architectural elements, benches, and seating areas available too.

The beach is very popular location in southern California, but our relatively featureless beaches rarely have rocks, outcroppings, or other features to pose the teens on. I try to steer subjects away from beach shots unless the beach is an integral part of their life. When there's no getting around shooting at the location, I always make it our last stop and limit the session there to just a few minutes.

In the absence of specific location ideas, I often have the subject get in my car once the classic portraits are done. I drive around the neighborhood and in most cases, within a few minutes, we find places and things that have meaning for the kids. Sometimes, a fence that runs the perimeter of the house or a street corner with beautiful landscaping is a good location. Almost every neighborhood has empty lots, open fields, small hills, and parking lots that the kids can direct you to. For this reason, I always bring along

You don't need much space when photographing one individual. Learn to look for small landscaped areas in good light. Here, we worked in a small area of the girl's backyard. With a shallow depth of field, the background was blurred to create the perfect environment for her images. Both images were captured with a Nikkor 50mm lens set to an aperture of f/1.8.

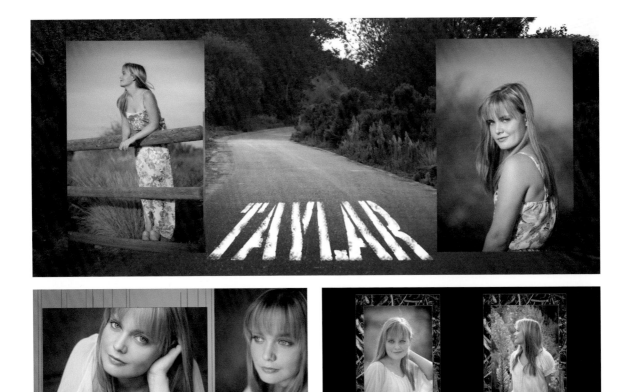

Here are some of the images made during Taylar's session. Two of the pages feature images made on location. The third features shots made at Taylar's home, using the backdrop I brought along for the session. I try to schedule senior sessions so that once the classical portraits are made, there is still enough time to take advantage of "sweet light"; just before sunset, the light is soft and flattering.

■ TAYLAR'S SESSION

I've photographed Taylar's family for a few years, and I was delighted to be asked to create her senior portrait. I like to start with a mini natural light studio session either at the senior's home or mine. When I arrived at Taylar's home, she had her clothing options laid out. I quickly reviewed the outfits and helped her narrow her selection down to two outfits: one for the classic images and one for the location shots.

While Taylar changed into her first outfit, I set up a natural-light studio in the kitchen. The home's French doors served as my light source. I knew the muslin with deep greens and blues would complement Taylar's beautiful blue-green eyes. We took a series of classic head-and-shoulders shots, then I shot other angles of her face, capturing different moods. It is my goal to sell a senior album, so for these sessions, I try to capture images with extra room for text.

Once we had enough classic portraits (this took about thirty minutes), I had Taylar change into her location outfit, and I packed up my gear. We then drove to a nearby location to finish the shoot.

a chair or stool for the subject to pose with. My favorite is a wire-backed green chair with a trendy look.

Working with Young Men. Young men can be more challenging to photograph than young women. They are normally more reserved and not used to being photographed. To help them relax, I ask them questions about school and sports. Once they start talking, they begin to relax. Sometimes I ask male subjects to help me set up equipment, carry something, or in some way help me. This can help to break the ice too. Finally, I ask male subjects to bring favorite items to use as props. An athlete can bring his letterman jacket and some equipment, and a musician can bring his instrument. You can also incorporate books, art, trophies, ribbons and medals. Thinking about their passions and accomplishments can help increase their confidence, and the prop gives you an opportunity to discuss his interests.

Offer Something Different. Years ago, a client asked me to photograph more than a single senior session for her teen. She

■ HAIR AND MAKEUP

I find that most high-school girls like to do their own hair and makeup. However, if you can talk parents into allowing their daughter to have her makeup done professionally, it will tremendously improve the quality of the images that you produce. I suggest to the mothers that they make this a special treat for their daughters—something like a spa day.

When working with girls age 11 to 14, I always discuss makeup with the parents before the shoot. I find out what the parent will be happy with, then I talk with the teen. I recommend she wear light makeup to please her parents and tell her that she can change her look at the end of the shoot, and I will take images for her.

For senior books, I typically start at the subject's home, then move to a location. These spreads from a boy's senior book were shot in my own home. I asked him to bring his letterman jacket for the shoot. For books made for the guys, I like to use grunge-type looks. For girls, I like to use a cleaner look with lighter colors.

wanted me to capture each dance, sporting event, family celebration, and ceremony. I accepted the assignment, and I had her pay for the senior session up front, then I was put on retainer for the remainder of the year. I came up with a reasonable charge for going out on location to photograph the several events during the year. At the end of the school year, a book was created to capture the entire senior experience. This is now a popular service offered at my studio.

7. LIFESTYLE PHOTOGRAPHY

FACING PAGE—Lifestyle images showcase the child at rest or at play, acting naturally in front of the camera for a more relaxed, spontaneous portrait feel. BELOW—Capture a child's many moods for maximum portrait sales. Photos by Marc Weisberg.

NATURAL MOMENTS

Portrait photography has changed dramatically over the years. It is no longer stiff and formal-looking; in fact, today's clients want casual images that document real-life moments and help to tell the story of the person in front of the lens. In children's portraiture, the subjects are often photographed engaged in play, with telling expressions, and in meaningful locations. The images parents seem

to prefer capture not just a likeness of the subject but something about who the child is.

While the trend in children's portraiture is a more relaxed, natural feel—something a gifted amateur shooter might be able to capture on a good day—photographers must have a strong background in portrait technique, an ability to consistently turn out well-executed images, and a well-formed business strategy in order to be a success. As Marc Weisberg said, "As good as a camera may be, it is still the photographer who makes the images. And there is a world of difference between a snapshot and a skillfully crafted image."

A boy and his dog, photographed in natural light. Everything about this image is relaxed, but it's clearly a professional shot. Photo by Jason Romero.

##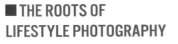

THE ROOTS OF LIFESTYLE PHOTOGRAPHY

The lifestyle portrait trend seems to have started in Australia. For years, Australian portrait photographers have seemed to favor looser, freer images with an unposed feeling. They've produced children's portraits with a vibe that is well suited to the easygoing Australian lifestyle.

Lifestyle portraits have an unscripted, photojournalistic look. Photo by Rebecca Lozer.

NATURAL LIGHT

To create dynamic lifestyle images, you will need to have a strong understanding of light and particularly how to work in natural light. In chapter 12, I explain how to use the natural light in the location you are using. When capturing images outdoors, you don't have control of the light, as you do when you work in the studio. To become a good lifestyle photographer, you need to learn to find good light—directional, soft, subject-flattering light.

Lifestyle images are all about the subject reacting to their environment—and when you put a child, teen, or family in that environment to tell the story of who they are, you'll find that the existing light plays a major role in creating a real-life, candid feel.

MY PATH TO LIFESTYLE PHOTOGRAPHY

Early in my career, I was shooting almost exclusively in the studio. My studio had beautiful natural light, and I took advantage of it whenever possible. At the time, I captured primarily traditional portraits, but as time progressed, I wanted to make a change. At first, I photographed subjects in costumes and props. Later, I moved my studio to a commercial location. While I still had beautiful natural light, I also had an industrial urban area to photograph in. I had access to brightly colored factory walls and commercial architecture. It was a wonderful area for conducting sessions.

While I enjoy creating lifestyle images, I find it challenging at times. I have always loved the photographer–subject connection that studio photography allows. In lifestyle photography, that connection isn't there. To me, location portraits have a more photojournalist style; it's a more detached experience.

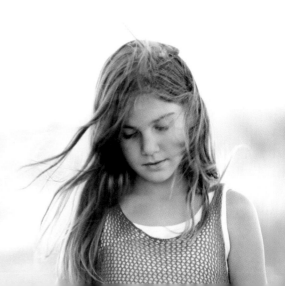

Today, I take both lifestyle and classic portraits for my clients. I find that classic portraits make up the lion's share of my portrait sales, but I have seen the purchases of smaller lifestyle-image prints picking up. As a large portion of sales come from albums and books, it was important for me to learn to capture more illustrative, photojournalistic images. I find that the lifestyle images work well as transitional and background shots in a book. As I have become more skilled in lifestyle photography, I have seen my images take on a more stylized, commercial look.

The other benefit of becoming better at lifestyle photography is the possibility of creating images for stock photography or other

Lifestyle images work well as transitional and background shots in a book.

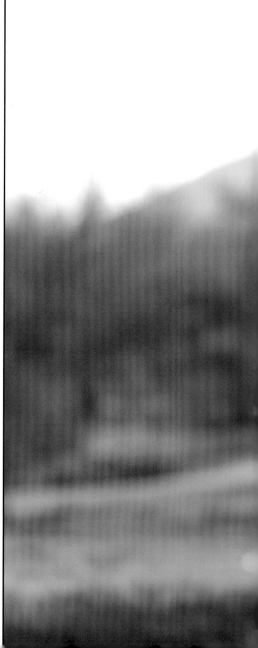

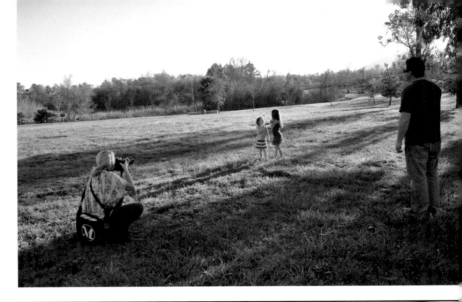

RIGHT—This pull-back shot shows the site of the session and my perspective of the subjects. **BOTTOM LEFT AND RIGHT**—For this session, I talked with the little sisters, giving them limited directions. I then let them play and patiently watched and waited for charming interactions.

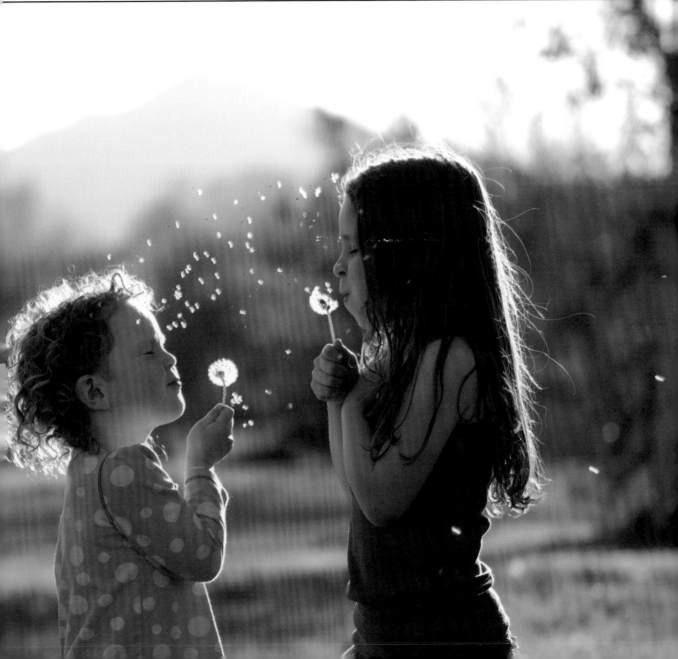

avenues of revenue. As it becomes more difficult to earn money from only one genre of photography, expanding your horizons can help lead to success.

Recently, I have used the tools of a wedding photographer. I initially talk to my client about posing ideas, then step back and let the client pose without constant direction. I do tell them to try and look toward the camera at times, to interact with the other subjects, and not to look directly at the camera and smile.

This session was photographed on the beach. It's the perfect location for a fun-filled lifestyle shoot.

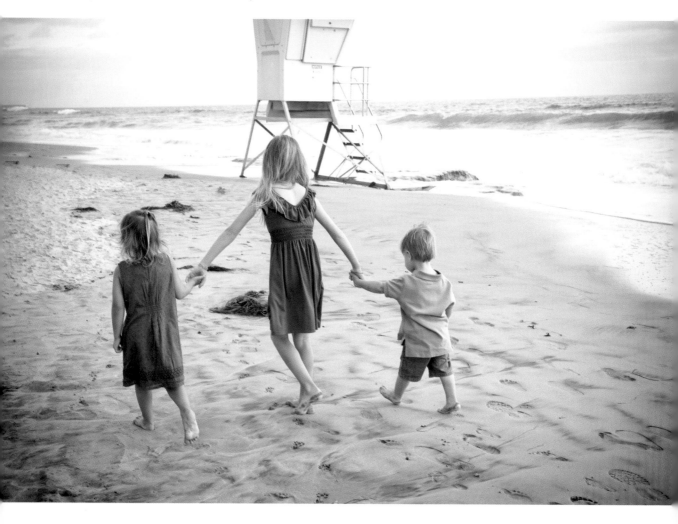

8. THE CONSULTATION

Asking questions and
generating excitement
about the session will
help book clients.

For the professional photographer, a pre-session consultation is a critical foundation for a successful portrait session. In talking with the clients, in person or on the phone, the photographer can learn about their expectations and what they want to get out of the session. It is also a good time to learn about the child's temperament, likes, and dislikes.

EXPERIENCES AND EXPECTATIONS

I do my consultations over the phone. (If you have a storefront studio, it may be best to have clients come in for a consultation.) Once a new client has seen my web site and contacted my studio, I know that they are sold on my imagery. Therefore, during the phone conversation, I have to close the deal. I have found that asking friendly questions and generating a sense of excitement about the session will help book clients, whether over the phone or in person.

A great hat can help frame the face and add texture and interest to a portrait.

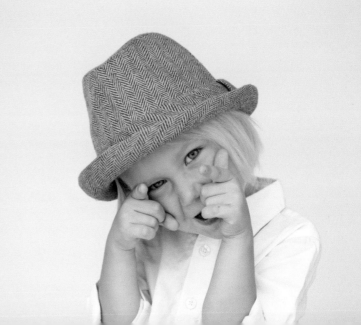

During the consultation, I like to ask the client pointed questions that will help me identify their wants and needs. I inquire about their previous portrait session experiences. What worked? What didn't? Armed with this information, I can develop a game plan for the session. I try to determine what the client is looking for from the session. Does she want to do images in her home or on location? Who will be in the images? Should the portraits be more contemporary or traditional? While we are conversing, I allow the clients to express what they want to tell me about the

I like to ask the client pointed questions that will help me identify their wants and needs.

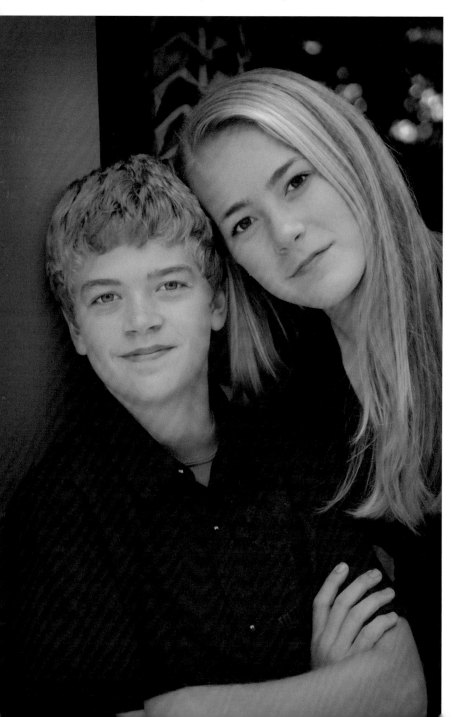

Dark clothing helped to create a unified look in this image and kept the focus on the subjects' faces.

A subject will feel confident when she wears clothes she feels good in, and her positive self-esteem will be evident in the resulting image. Photo by Kim Treffinger.

family and the family dynamics. This makes them feel that they have connected with me.

CLOTHING

During the consultation, the client will invariably ask about clothing. The type of clothing that is appropriate for the session depends upon the type of session that's planned. If the client wants traditional portraits, you will need to find out if they're interested in a formal or casual look. I recommend solid-colored clothing without patterns and with a simple cut or design. I feel that a traditional portrait should stand the test of time; it should not look dated in 20 years. If you have the client bring two sets of clothing

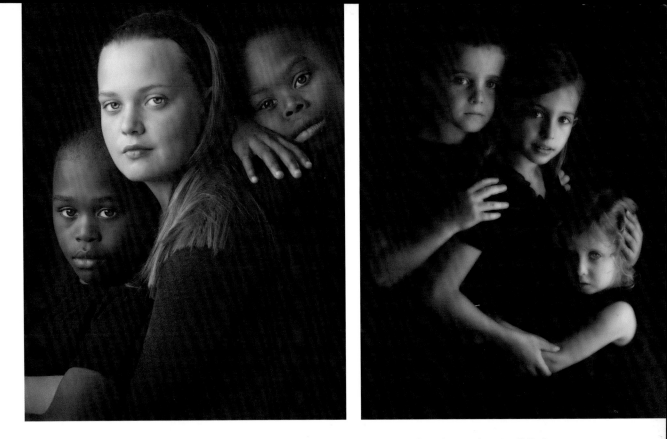

FACING PAGE—This ballerina costume called for a more traditional, understated portrait approach. Photo by Kim Treffinger. ABOVE AND RIGHT—For a cohesive look, keep clothing simple when photographing a group.

■ GO SHOELESS!

I suggest that my clients go shoeless for their session. Shoe styles are always changing, and shoes can date the image. Also, children's feet can add a lot of charm in an image. Of course, if the session is being held on-location, the subjects will need to protect their feet. In that case, shoes should suit the clothing and location.

to the session, one all dark-colored and one that is all light tones, you can create a variety of images. Also, some clients look better in dark colors than they do in light colors (or vice versa), so having an extra outfit at hand can be helpful.

Formal Portraits. For traditional portraits, formal clothing is a good option. Appropriate clothing choices include special-occasion dresses for girls and suits for boys.

Natural Light Studio Portraits. For this type of image, T-shirts or button-down shirts in solid colors with no patterns or designs are preferred. These can be paired with matching or coordinating pants or shorts.

Outdoor Lifestyle Images. Bright colors and lots of texture—along with hats, scarves, and jackets—are great options. Shoes suitable for the environment are encouraged, too. (I prefer to photograph kids without shoes, but safety comes first!)

A CLOTHING KIT

It is a good idea to collect a few of your own wardrobe selections on hand that you can use in a pinch. Keep them clean and store them in some type of portable container that you can easily take

on location. Clothing and accessories to have on hand include but are not limited to:

- Dark-colored fedoras, straw hats, berets, stocking caps, and cowboy hats.
- A pair of cowboy boots in a larger children's size that can be used for sessions with smaller kids, too.

This subject lives in Europe. Prior to the session, I gave the mom some ideas for clothing that would work well for the shoot we'd planned. On the day of the session, I arrived at the home early. The mother had laid out several outfits and accessories. I added hats, sweaters, jackets, and scarves to the outfits, creating new ensembles that the girl normally would not have worn. By simply rearranging the outfits and layering the clothing, we were able to come up with some adorable outfits to take on location. The mom and I were thrilled with the results.

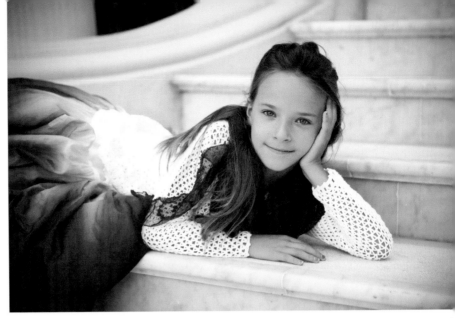

Here are two more outfits we selected for the girl's session. Note how well the clothing coordinates with the surroundings.

- Bandanas and scarves in a variety of neutral, bright, and dark tones.
- Unique pieces from discount or second-hand stores. Consider bolero jackets, vests, denim jackets, large cable-knit sweaters in neutral colors, and a dress jacket or two. I recommend getting most of these in size 10 or 12. These clothes will fit many kids, and younger kids can wear the oversized jackets—they look adorable in too-big clothes!

LEFT AND RIGHT—I asked the mom to bring several outfits—plus hats, scarves, and jackets—to my house for this session. Having the parent and child participate in selecting clothing and unusual accessories helped make this session a success. **FACING PAGE**—Some playful clothing options for this shot, made in my backyard, provided for a portrait with lots of personality.

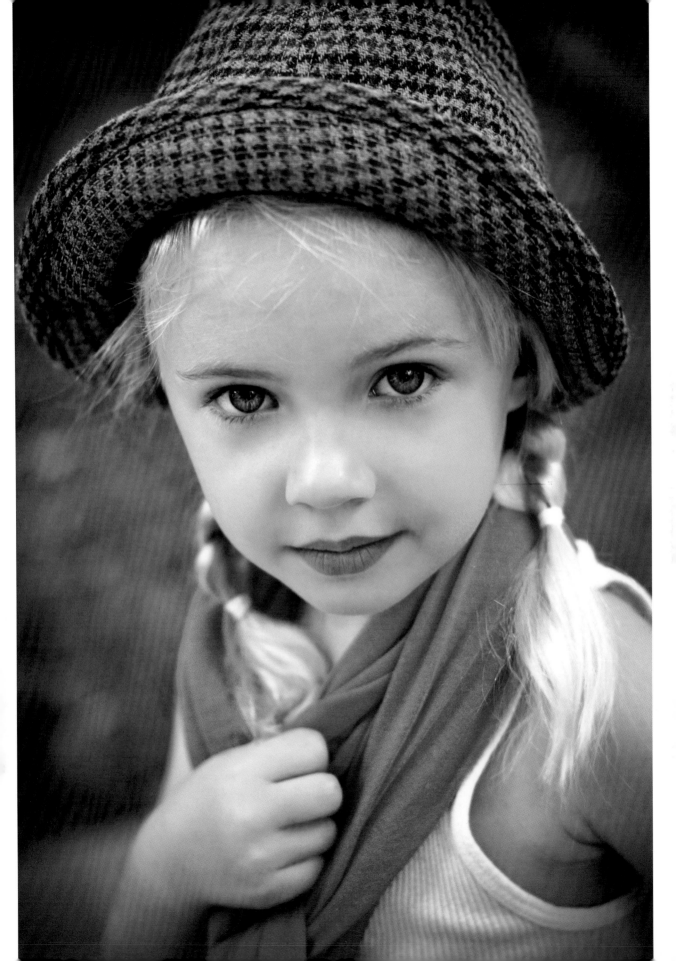

9. POSING

An awkward pose can ruin a portrait. Solid technical skills, perfect lighting, beautiful backgrounds, and a fabulous outfit won't carry the image if the subject appears unnaturally posed and stiff. Early on in my career, I learned about posing by studying photographs and paintings in museums, books, and in film. I've found that as you view and study good art and imagery, you create a bank of stored images in your mind that will help you gauge what looks correct and natural. As you work with your

Sometimes including a parent in the frame is the only way to get a young child to settle down.

I find that the easiest way to get the pose I am after is to model it for the subject first.

subjects, you will learn to intuitively move and coach them into poses that look and feel natural.

Today, most families prefer casual, relaxed lifestyle images. While lifestyle portraits appear natural, unrehearsed, and not controlled by the photographer, posing basics are still critical. A good photographer coaches and directs the child into the position that affords the best light and background. Additionally, to create the best-possible image, you need to evoke emotion to elicit an expression that will be pleasing to the viewer.

Today, most families prefer casual, relaxed lifestyle images.

EFFECTIVE POSING STRATEGIES

Start the session by talking to and connecting with the child. When I am working with a very young child, I like to show her

my equipment and tell her what I will be doing. At times, I take a quick photo and show it to her. I show her my finger puppet and a squeaky stuffed toy I use to get giggles, while I talk about getting tickled. For elementary school children (ages 5 to 10), I ask questions about school, teachers, and favorite things. I ask older children to tell me about any sports and activities they are involved in. Once you know a child is comfortable with you, try suggesting some basic poses. Model the poses yourself. As the child begins to copy your poses, observe her. Take note of her best features. Rework your initial pose to accentuate her assets.

PEOPLE AS PROPS

For many little ones, including a parent in the frame may be the only way to get the photos you're after. Have the parent hold the child and turn so that you have a side view, then ask the parent to turn their head slightly away. When the child looks at you, use a wide-open aperture, f/2.8 if possible, and let the parent's image go soft and blurry while keeping the child in sharp focus.

Parents can also stand in the background, adding a relationship element to the image.

For many little ones, including a parent in the frame may be the only way to get the photos you're after.

Here, the mom is shown in the frame, but the toddler is undeniably the star of the show.

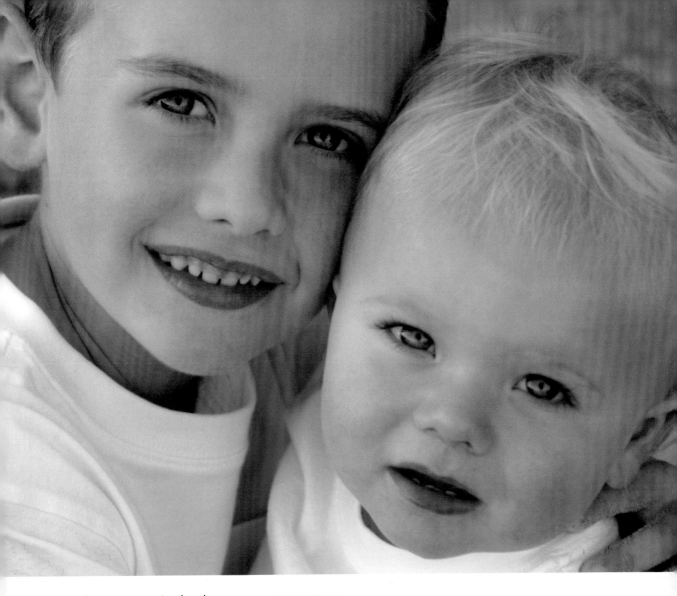

Here, a close crop, varying head heights, and beautiful lighting makes for a perfect image of two young brothers. Photo by Jason Romero.

POSING SIBLINGS

When you are photographing children of varying ages and heights, you should step back and look for ways to physically connect them. Positioning the subjects in a triangular arrangement is an easy solution. Place the tallest in the back and two shorter kids on either side, then have them connect their arms. To emphasize the subjects' emotional and interpersonal connection, I place children very close together, with heads, shoulders, arms, and hands touching. Most siblings, especially pre-teens and teens, will give you a hard time when you ask them to touch each other. This is when I give them the "if you were a top model" talk. I ask them, if they were being paid big bucks as a famous model, would they

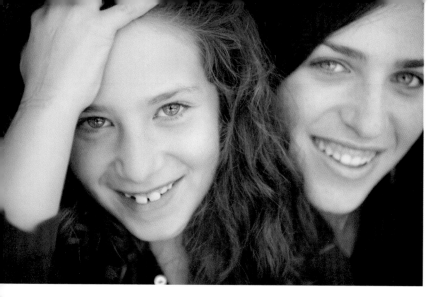

Compositions in which siblings are physically close, often with linked arms and hands, help to illustrate a close family bond. It's an approach that parents respond to.

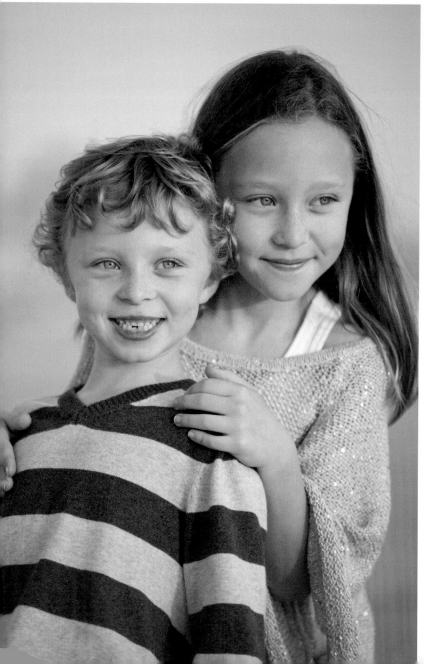

agree to touch another model? I suggest they see this session that way because—who knows?—one day they may get to model for a magazine, and this will give them practice.

RAPID POSING

An approach I initially used for high-school senior sessions is now my go-to method for posing any child who is old enough to follow directions. Once the kid is comfortable with me and is responding to my directives, I recommend that we do a series of rapid poses.

Over the years, I've identified the poses that have appealed most to parents. Parents buy images in which the kids are posed in a way

Over the years, I've identified the poses that have appealed most to parents.

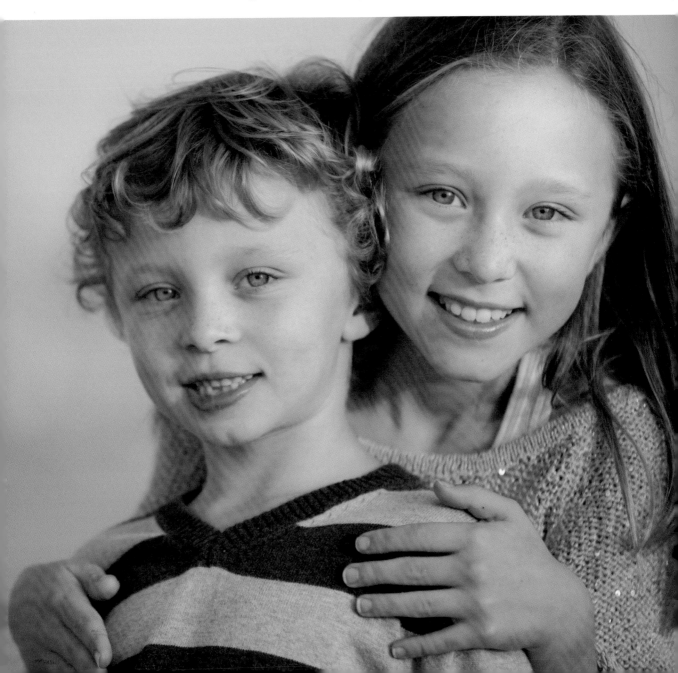

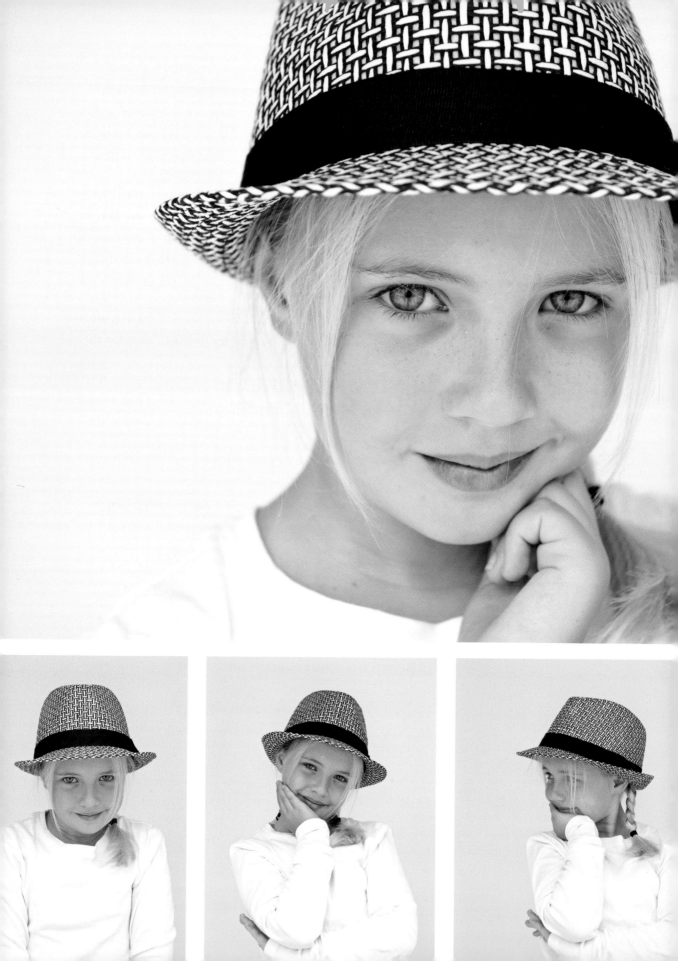

that appeals to them, so, of course, I try to work toward creating images that feature those poses during every session.

I tell my subjects that I want them to pose like a model. I place myself in their spot and show them the series of poses I want to see. I explain that they are to move from one pose to the next with each click of the shutter.

Using a stool or chair, I sit with my legs turned away 90 degrees from the camera, with my body angled back toward the camera. Then I quickly show the child 3 or 4 different ways to pose in that position. The posing continues as I rotate my knees toward the camera and do the same 3 or 4 poses. Finally, I turn my knees 180 degrees in the other direction and complete the same 3 or 4 poses.

The child won't copy exactly the pose you show, and that's a good thing. You simply want them to feel confident in what they are doing and keep moving.

I take a similar approach to posing young children on the floor. In this case, I have them lie down on their tummy and do a series of poses with their arms, making sure to capture their profile in the process.

POSING DO'S AND DON'TS

Posing will seem less daunting when your keep some general principles in mind:

- Let the child warm up to you before you start taking photos. Connect with him by asking questions and getting him to help you set up, select the portrait location, or give you posing ideas.
- If the child's lips are dry and pale, ask her to bite and lick them. Instantly you will have healthy, attractive, and natural-looking lip color.
- Always get photographs of the child's full body, as well as sitting. Capture head-and-shoulders images, profiles, and close-up shots of the face.

Rapid posing—having your subject make slight adjustments to their position as you click the shutter button—can yield a great variety of images, with little extra effort.

- Use a shallow depth of field to focus on the child's eyes in the image.
- Many photographers like to take photos of kids jumping so that they seem suspended in midair. If you do so, make sure that the area is clear and safe and that there are no objects for the child to get hurt on.
- It is not a good idea to have young children say "cheese" to get them to smile. When you do so, you will get a forced, toothy grin. I prefer to ask young kids to say words that end in Y. Sometimes I ask them to name their favorite candy or ice cream. I've found that getting a kid to think about his favorite treat will often make him smile.
- Never have children stand or sit in high places. I recently saw a session posted on Facebook where the photographer placed the toddler on the kitchen counter and had the parents across the kitchen, out of focus. In a split second, that child could have fallen off the counter!

POSING AND COMPOSITION

Posing and composition go hand in hand. In the next chapter, you'll learn how and where to position the subject to create an image with impact.

Images of kids being kids have great sales potential.

■ GREAT LIFESTYLE IMAGES

1. Look for unique and colorful backgrounds.
2. Ask the child to act silly. Suggest that he run toward you, then suddenly stop.
3. Capture the child running across the image area.
4. Get the child to laugh and play.
5. Children love to play in water, and it creates a lot of visual interest. Consider creating silhouettes with the sun behind the moving water—if the parents don't mind!
6. Have the parent bring favorite toys to the session. They can be helpful posing aids.

10. COMPOSITION

Composition is like a string that travels through an image, pulling all of the visual elements in the photograph together to create visual interest. There are many established compositional rules and guidelines for effective composition. These strategies will help you determine where to place your subject in the scene and how to use other elements of the image to draw the viewer's gaze into and around the frame of the image, locking her eyes on the main subject.

THE RULE OF THIRDS

The rule of thirds is a method determining effective subject placement. I intuitively use this method in every image I shoot.

Here's how it works. Imagine dividing your image into thirds, both horizontally and vertically. To do so, you would draw two

When you look at a close-up image of a child's face, you might not think about composition—but it's there. Here, the face was cropped tightly to give a sense of drama and emphasize the child's eyes. The image would not be the same if I'd pulled back for a head-and-shoulders presentation.

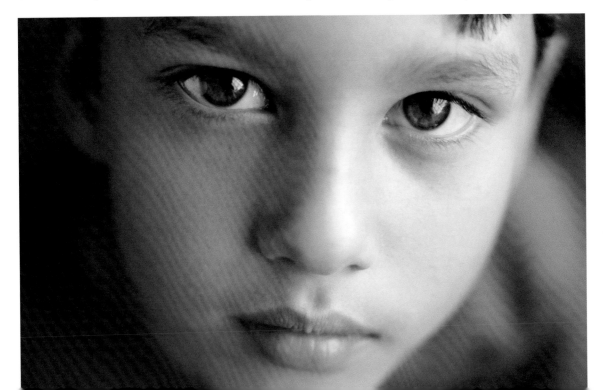

equally spaced horizontal lines and two equally spaced vertical lines (picture a tic-tac-toe board superimposed over your image). The rule of thirds states that optimal subject placement is achieved when the subject is positioned at a thirds line—particularly at one of the power points—the four areas where the lines intersect.

I like to place a dominant element in the upper or lower third of an image. It can be a child's eyes in the upper third or a full-body shot with the kid in the left or right third of the image frame.

TRIANGLES, S SHAPES, AND C SHAPES

When composing an image, photographers often seek to incorporate shapes that have been traditionally considered pleasing to the eye. The most popular shapes are the S shape, the C shape, and the triangle. Sometimes, these shapes are naturally occurring: for instance, a winding road might take the shape of an S. Other times, it's the pose that introduces the desired shape in the image.

Triangular Shapes. The triangle is a good, strong compositional element. The diagonal lines draw the viewer's eye through the frame, and the horizontal base of the triangle grounds the image. The triangular shape, no matter how it is created, brings a feeling of balance to the image.

When posing a group of three kids, you might create a triangular shape by positioning the tallest child in the center of the frame,

LEFT AND RIGHT—These images show the rule of thirds at play in a vertical and horizontal composition. Most cameras today offer the option of viewing a rule of thirds grid superimposed over your scene. This makes it easy to effectively position the subject. **FACING PAGE**—The negative space in this composition draws the viewer's eye directly to the subject. Photo by Rebecca Lozer.

■ NEGATIVE SPACE

If I want to create a dynamic composition that pulls the viewer's gaze into the image, I will place the child off-center to the far right or far left, leaving a large area of negative or empty space beside the child.

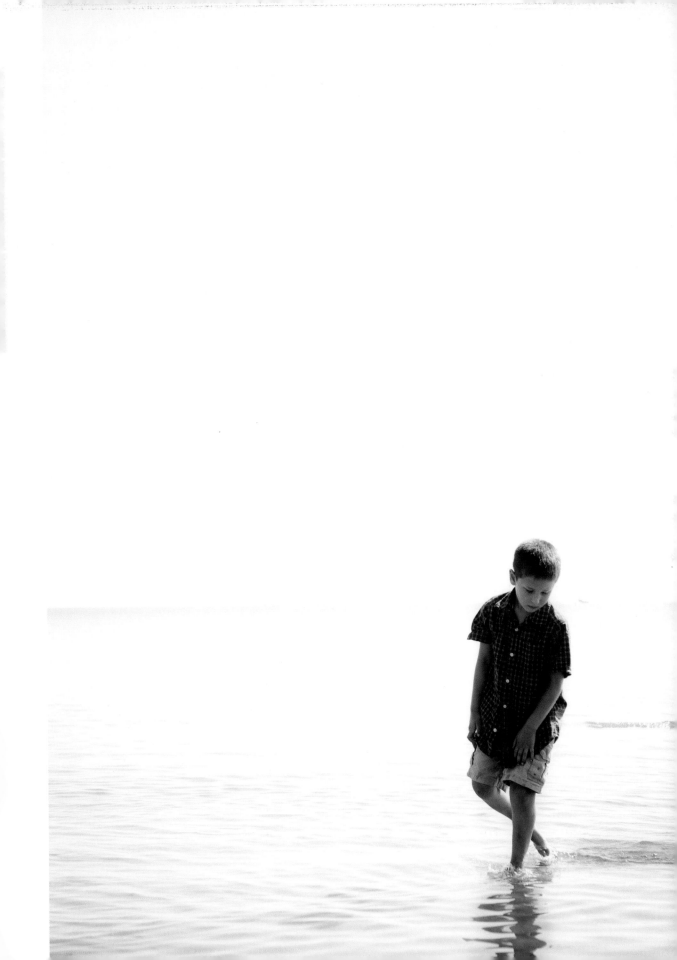

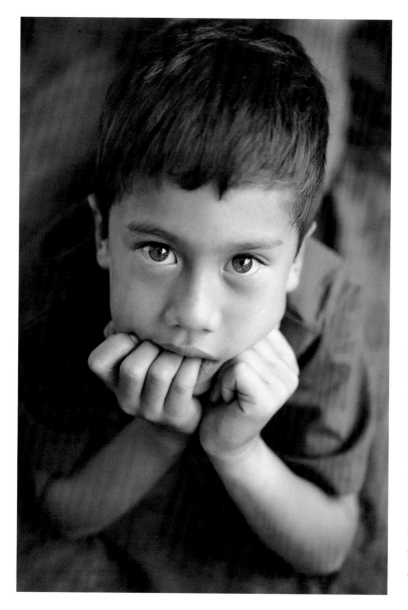

A triangular shape was introduced in this child's pose. Note that the lines from his right elbow, to his head, to his left elbow create a triangle, and the space between his elbows closes the shape, creating a base, or grounding element, for the portrait.

■ WHAT'S YOUR ANGLE?

When you are starting out as a photographer, take images from several different angles and directions. In time, you will start to see what creates the most pleasing image. When I'm photographing a child, I always photograph the face very close, then take a partial head shot, then finally, I create a full head-and-shoulders portrait.

with his two siblings positioned on either side of him. This would cause the viewer's eye to move through the frame, from the first face on the left, to the tallest child, to the third face, on the right. When posing an individual subject, you could create a triangular composition by positioning the child in a seated pose at a desk or table with his elbows resting on the surface and his hands lightly clasped near the center of his chest.

S and C Shapes. C- and S-shaped compositions also help to guide the viewer's eye through the frame. You could use a C curve

to add interest in the image by having a mom with her son in her lap turn to a profile position to the camera, with the child leaning into the parent. In addition to creating a compositional element, the pose would evoke a sense of love, security, and affection.

An S shape introduces a sense of movement in the image. You might have an outdoor image with a winding path that draws the viewer's eye through the image, for instance. You might also coax a figure-flattering S curve out of a female subject while shooting model-type images. For example, by positioning her turned at a slight angle to the camera, you might have her spread her feet slightly apart, with one foot behind the other. With her weight on her back leg and her front knee slightly bent, her hip would shift slightly to one side. By dropping her back shoulder and turning her head back toward the camera, you'd create a captivating, flattering, dynamic S shape.

An S shape introduces a sense of movement in the image.

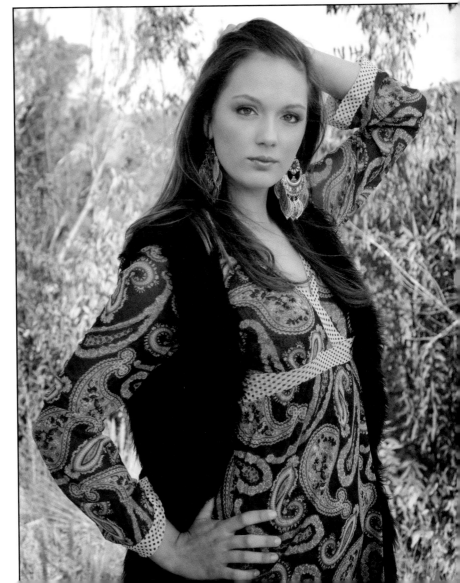

An S shape can be introduced in the composition through the pose. Here, that shape begins in the upper-left of the frame, with the subject's bent arm and can be traced down through her body to the curve of the hip at the bottom-left of the frame.

TOP—A C curve is a powerful and pleasing shape in portraiture. **BOTTOM**—Two triangles were created in this composition. These shapes help lead the viewer's eye through the portrait and focus attention on the key areas of the image.

HORIZONTAL, VERTICAL, AND DIAGONAL LINES

Lines—real or implied—can pull the viewer's eye into the image. They create a feeling of movement in a photograph. Lines that extend to the edge of the image should pull the viewer's eye into the scene, not out of it.

 Horizontal lines create a sense of harmony, stability, and calm. As you look at your scene, use horizontal lines or implied horizontal lines—e.g., the bend of an elbow or an arm drawn across the frame to lend a sense of peace and serenity to the image. Vertical

FACING PAGE TOP—The horizon line in this lifestyle image helps to create a feeling of tranquility. Photo by Rebecca Lozer. **FACING PAGE BOTTOM**—Repeating vertical lines, like those seen in the background of this image, can be pleasing to the eye. Photo by Rebecca Lozer.

lines are related to a sense of dynamic movement. They may be useful when photographing a high-energy child, or when you want to show a full-body shot and need something else in the frame (e.g., a tree trunk or an architectural column, maybe) that has the same visual weight. Diagonal lines are also very good for pulling a viewer's gaze through an image from right to left, bottom to top. Repeated lines of any variety can add a nice graphic element and introduce a sense of rhythm in the portrait.

BALANCE AND TENSION

A photograph that creates a sense of harmony, equilibrium, and an even distribution of weight is said to be in balance. To create a balanced image, you must evenly space objects or ensure that objects have the same relative size and visual weight. For example, if you have several small objects on one side of the frame, you can balance them by placing a large object on the opposite side.

Balance can also be achieved in the tonal values of the objects. If there are dark elements on the left side of the frame, you can place dark-toned objects on the other side of the frame to create a sense of balance.

Balance is an important concept in children's portraiture, as the majority of the images you produce should exude a feeling of

Diagonal lines introduce a dynamic feeling to the image.

With large areas of skin tone on the left and right sides of the frame, there is a sense of balance in this image.

harmony and calm and should create a positive feeling for the viewer. To achieve balance, be sure to not have objects that are brighter, darker, or heavier than the child in the image. Also consider using triangular or circular shapes when photographing kids. These shapes are viewed as pleasant and harmonious.

Tension is created when objects or image elements do not appear where the viewer expects them. You will see this quite often in advertising photography, primarily when there is a need for open space in which to put type. This open space is used to pull the viewer's gaze toward the product. Leaving an unexpected amount of space between the subjects can create a feeling of playfulness and spontaneity.

Note that when working with young children, you may want to avoid moving them around to achieve the best-possible composition. Once the child is posed, you may want to seek alternative camera angles or positions to improve the overall composition.

Tension is created when objects or image elements do not appear where the viewer expects them.

The teen in the foreground is much more prominent than the father in the background. The composition shows the effective use of tension.

COLOR HARMONY

Color has the power to evoke emotion and enhance the mood in an image. Cool colors create a feeling of remoteness and have a tendency to recede in an image. Warm colors evoke a feeling of comfort and stability and tend to advance in a scene.

To enhance the feeling of warmth in an image, coordinate the colors in the background and the clothing to help create the desired mood. Selecting colors that complement the skin tones will help you create the harmonious feeling you're after.

Color can also be used to guide the viewer's eyes through the image. By adding a dash of bright color with a hat or scarf, for instance, you can direct the viewer's gaze right to the child's face.

SUBJECT PLACEMENT AND ANGLE OF VIEW

Young Children. When starting the session, place the child in the middle of the compositional area, then move around looking for unique perspectives from which you can capture the child. Keeping basic design principles in mind, seek out poses and expressions you would not normally capture. Have the camera in a position above the child's head by seating the child on the floor or on

FACING PAGE—The bright purple scarf in this image helps to focus the viewer's attention on the little girl's face. **LEFT AND RIGHT**—Always capture a traditional head-and-shoulders image. Many parents like to present images with a more classic look to grandparents and other family members.

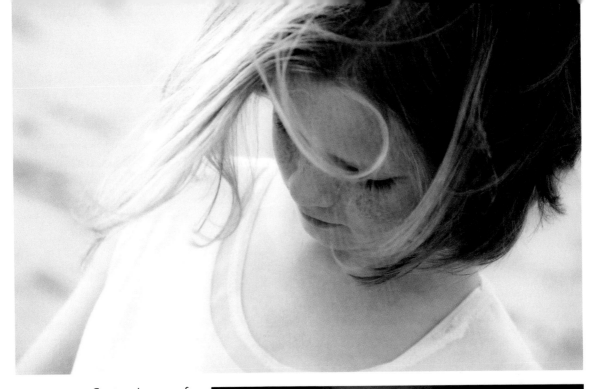

FACING PAGE—Capture images of young children from above eye level. Parents respond well to images that show kids from this perspective, as this is how they're used to seeing them. Photo by Marc Weisberg. **ABOVE**—An offbeat camera angle and interesting composition can be appealing for clients who prefer a modern look. **RIGHT**—Crop close for a heart-melting photo of a little one that parents are sure to love.

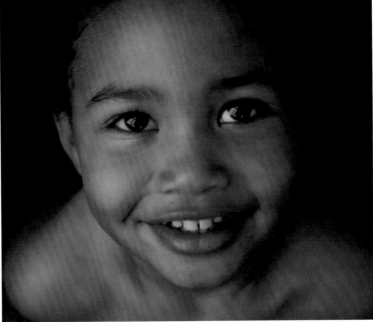

something that places them below camera level. Nothing evokes emotion from a mother like a portrait of her child looking up with those big eyes, the way she has seen the kid over and over again.

For the working professional, it is very important to capture the child in a traditional portrait pose, too. Regardless of the type of session I have, I always make sure I capture a classic head-and-

shoulders pose of the child, as I know that those images will be purchased for grandparents, aunts and uncles, and others. The older generations love classic portraits.

Older Kids. When photographing older children, I like to capture images of them doing things they love. I also like to photograph older kids sitting peacefully with beautiful light falling across their faces.

Older kids do a great job in following directions. I like to tell them to look off while I capture their profile or photograph their face from an overhead perspective. I can also give them a few ideas of poses and directions to look at, then step back and let them create their own poses and natural movements for the images.

Get in Close. I always try to capture a close-up of the subject's face, cropping the forehead to isolate the eyes, nose, and mouth. When doing this, I keep the aperture wide open (preferably f/2.8) so that the background falls out of focus. If you have a lens with an aperture of f/1.2 or f/1.4, come in closer and make a photograph with just the eyes and eyelashes in focus. This makes for a beautiful portrait. This approach works best with a lens over 70mm. If you have a 70–200mm, try zooming in and stepping back in order to capture just that little face and very little of the background.

One of my favorite lenses is the Tamron 17–50mm f/2.8. While I don't get as shallow a depth of field as my Tamron 70–200mm f/2.8 lens offers, it gives me the opportunity to move in very close and interact with the child as I take the photos. Keep in mind that shooting this close will cause distortion, and the nose may appear larger than normal in the image. I try to shoot at 50mm and back up a little to avoid too much distortion.

Get Down to Their Level. Getting down to a younger subject's level sounds simple enough. However, many photographers forget to do this. Squatting, sitting, or lying down so that you are on the child's level will help the subject feel more comfortable with you. You will often find me lying on my stomach, with my camera hoisted up, photographing young children who are lying on the ground. I highly recommend that you wear dark pants if you plan to work on the ground! For grade-school aged kids, try sitting on a short stool or a step ladder to shoot at their level.

ABOVE—Areas of strong contrast help to draw the viewer's eye in a composition. Photo by Terri Rippee. FACING PAGE—Get down to a young child's level for a great portrait look that's perfect for capturing a kid being a kid.

Squatting, sitting, or lying on the ground will help your subject feel more comfortable with you.

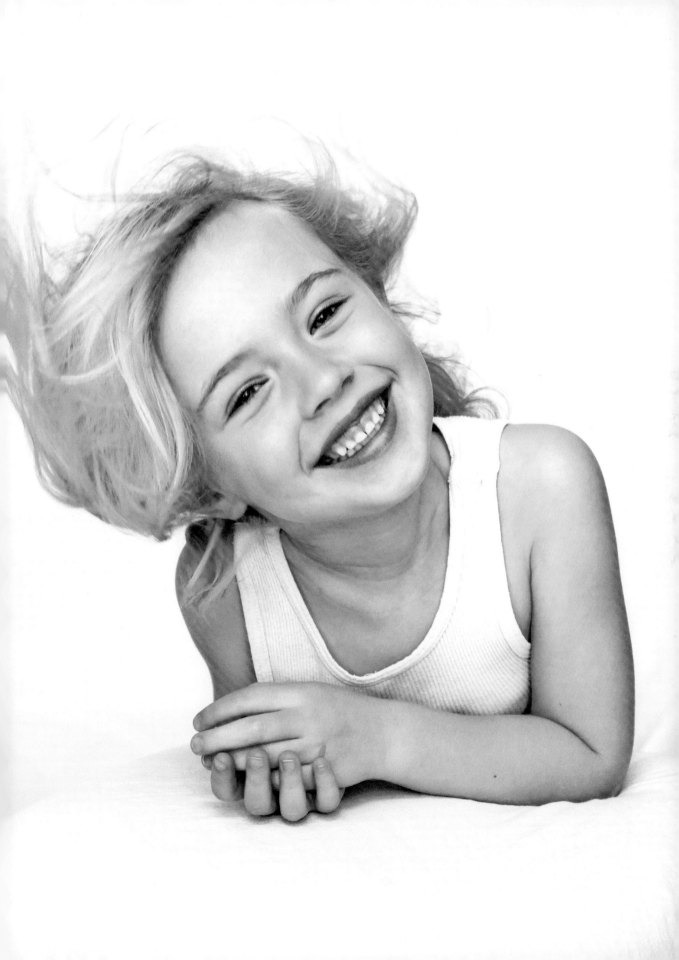

Move! Go ahead and play with the subject. Engage her. Lie on the ground with her, and then have her change positions. Have her sit on the floor so you can shoot from above. Have her move to a chair. Have her stand, jump, and even spin. All of these prompts can be made in a playful manner. (*Note:* This is a simple thing the hobbyist photographers can add to their repertoire!)

Create a series of images of a subject interacting with her environment. You can capture many different portrait looks in a short period of time. Variety encourages bigger sales.

THE EYES HAVE IT (SO DO THE FEET AND HANDS)

As you are working through the various points of view that you've planned to use to capture the subject, slow down long enough to capture a couple of images that parents really love.

Beautiful Eyes. The one thing parents want more than anything is a beautiful image of the child's eyes. You can choose a single point of focus on your camera, and capture the eyes in focus and the rest of the face softer by using a wide open aperture in the f/1.4 to f/2.8 range.

Tiny Hands and Feet. The younger the child, the more the parents love photos of the hands and feet. Ask the child to rest their chin on their hand, to sit with their knees pulled up, and to sit on their knees. Photograph them with their shoes off and take close-ups of those cute, pudgy little toes.

Always be sure the eyes are in sharp focus; the eyes are the heart of any image.

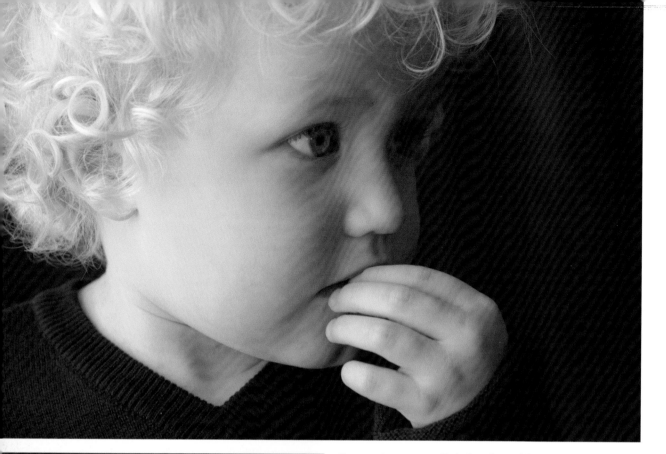

Parents love to see little hands and feet in their children's portraits.

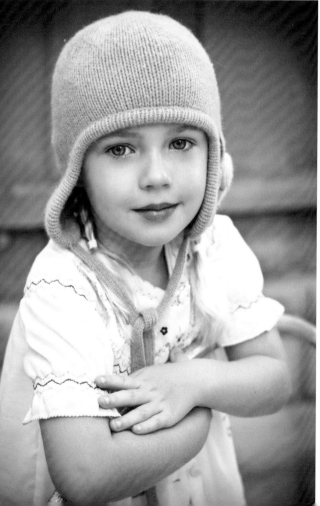

Photographer Michelle Lipowski loves working with children ages 2 to 5. After conducting her Bunnies & Babies sessions for over 13 years, she's come to realize that this age group, commonly considered very difficult to work with, is really quite sweet. Michelle says, "I love to play and ask the little ones my favorite question: What is your favorite ice cream? They tell me theirs and I ask them to guess mine. I tell them it has chocolate in it and something else that you put in a sandwich. I ask them if they think it is baloney, bacon, or onions. Of course, it is peanut butter!"

Michelle uses the following approaches for working with kids:

- **Ages 1 to 2:** I love to tickle or threaten to tickle the tummies of toddlers. They love it! I utilize lots of silliness and fun and games.
- **Ages 3 to 4:** Silliness and fun and games works well for this age group, too. I say a series of numbers and ask the kids to figure out which one I left out—1-2-3-5; 3-4-5-6-8. If they figure it out quickly, I say the numbers a little faster.
- **Ages 5 to 7:** When photographing kids in this age group, I use the same techniques I described above, but I also ask about the activities they are interested in, how old they are, and what kind of party they want to have on their next birthday.
- **Ages 8 to 10:** I ask these kids who the cutest boy or girl is in their class, what their favorite subjects are in school, and what type of sports they like to play.
- **Ages 11 to 14:** I talk to preteens about their interests. I tease the boys about girls, tell them they are doing a great job, and let them know how many portraits we are doing so they know I will move along quickly and wrap up soon. I encourage girls by telling them how nice they look, and I often comment that they look more grown up than they are. I tell them when they are doing a great job, too.

- **Teens:** I talk to these subjects about the activities they are involved in. I ask if they are looking forward to graduation. I ask if they plan to go to college and, if so, which one? Do they have ideas for a major yet? (Photo by Michelle Lipowski.)

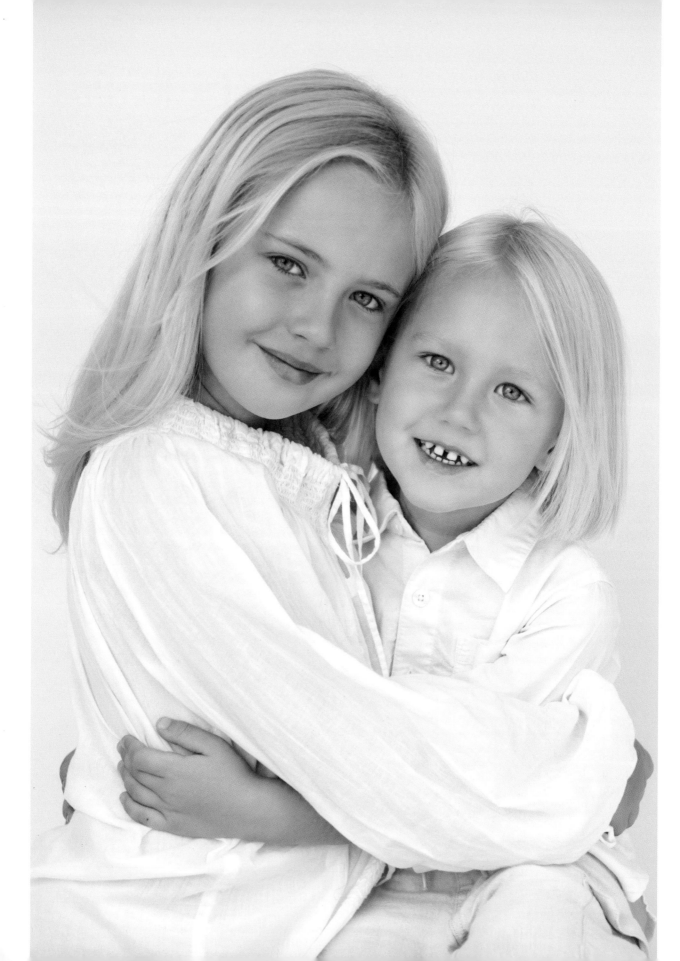

11. BACKGROUNDS

TAKE A PROFESSIONAL APPROACH

One glaring difference between amateurs and pros is their ability to incorporate the background into the scene. The background can be a distraction or an asset to an image. Follow the simple

The background can be a

distraction or an asset to

an image.

FACING PAGE—A classic white backdrop and a high-key approach helps to show off the beautiful, angelic skin tones of young subjects. RIGHT—The background, clothing, and poses must be harmonious for the best, most professional portrait results. Photo by Ally McKay.

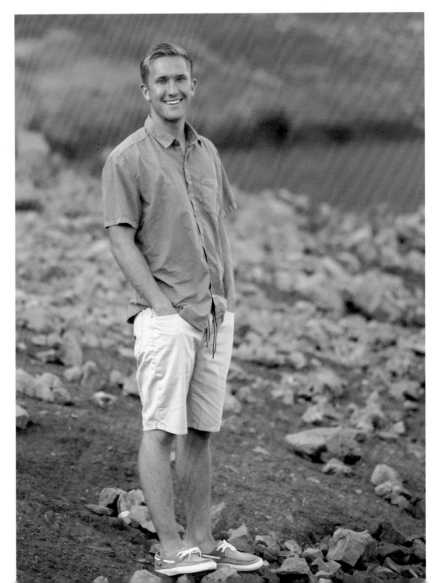

recommendations I provide in this chapter, and you'll find that your images look more polished than ever before.

LIFESTYLE/LOCATION BACKGROUNDS

For lifestyle photography, the background is critical to the telling of your story. Before pressing the shutter button, scan the scene for distracting elements and reposition your camera or the subject

LEFT—If you crop closely enough, even a couch can become an interesting, effective portrait background. BOTTOM LEFT AND RIGHT—Warm, earth-toned professional studio back-drops or store-bought bolts of fabric can work equally well as a background for portraits that will be displayed in a home with a traditional feel.

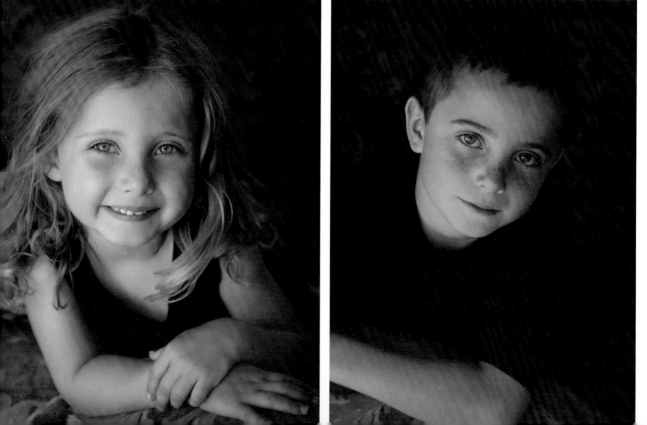

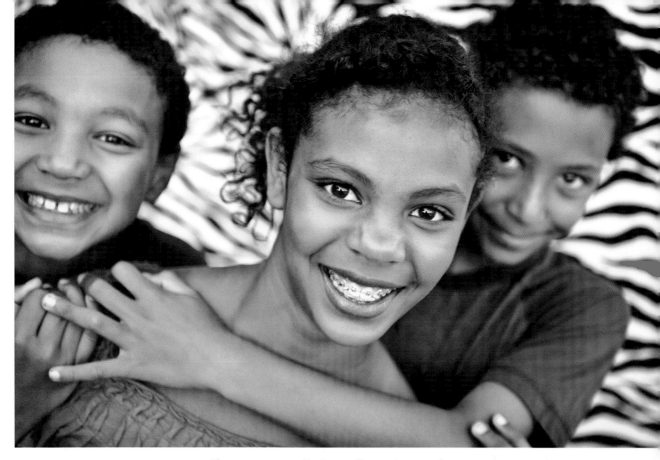

A zebra-patterned bedsheet lent a graphic punch to the portrait of these exuberant siblings.

BACKGROUND BASICS

1. When posing your subject, make sure he is at least 5 feet in front of the background.
2. When using window light, place the subject at the far edge of the window so that the wall behind the subject will appear darker than the subject.
3. You don't have to purchase expensive backdrops. Try using colorful bed sheets and lengths of fabric instead.

if necessary to eliminate distractions and create a stronger image. Granted, you can remove distracting elements in Photoshop after the session, but prevention is a better approach. If you're one of those people who finds it easier to say "I'll fix it in Photoshop," be sure the subject does not appear to overlap the distracting element. When this is the case, retouching the object out can be difficult.

CLASSIC PORTRAITS

For a classic look, consider using fabric backgrounds in rich colors. Reds, browns, and earth tones are excellent color options for images that will be displayed in a home with traditional décor. For a contemporary look, consider using inexpensive brightly colored or patterned bed sheets.

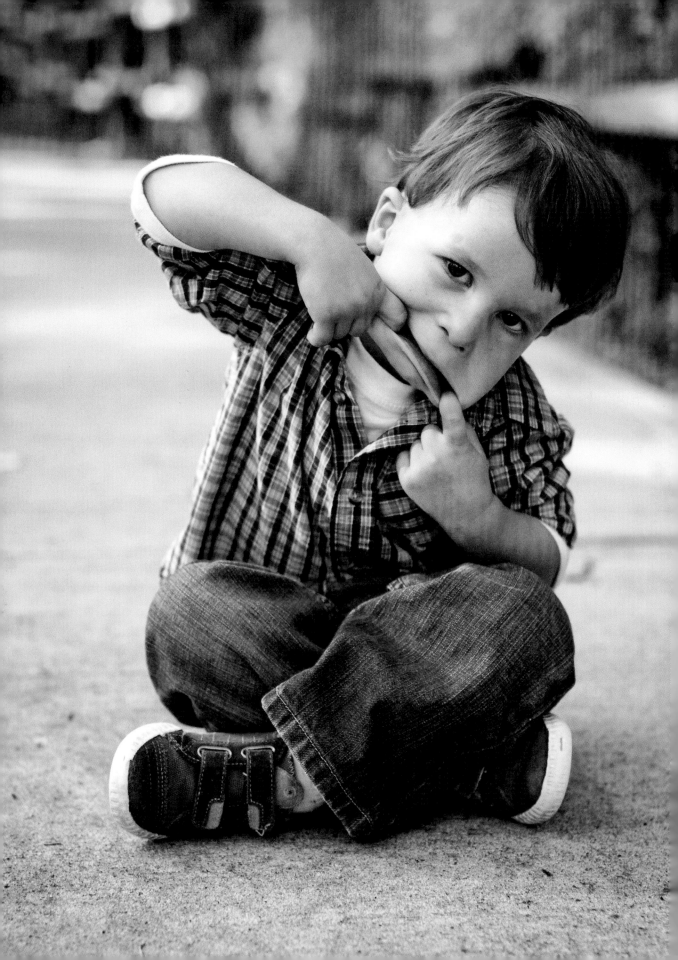

12. GREAT LIGHT ANYWHERE

THE BENEFITS OF LOCATION SESSIONS

Location sessions are popular with clients today, for good reason. For kids and parents alike, they are a more natural, less stressful alternative to the more confined, business-oriented studio environment. Clients and photographers have many options to choose from—beaches, state parks, playgrounds, architectural backdrops, and the client's own home or backyard are all viable options—and those are just a few of the many workable locations.

FACING PAGE—Outdoors, there are an endless array of background options available to intrepid photographers. Photo by Marc Weisberg. LEFT AND RIGHT—There are perks to working at the subject's home, too—you'll find that kids are most relaxed in a familiar environment.

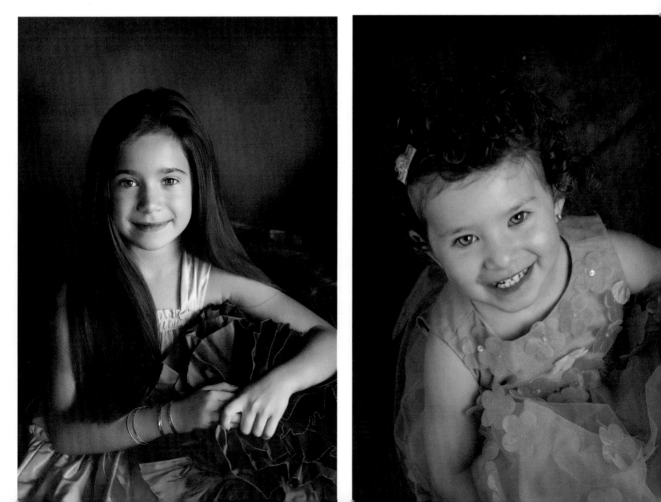

Conducting the session on location also offers some clear benefits to photographers. First, once you learn to find the best light and manipulate it using the techniques outlined below, you can create gorgeous images without a bag full of lighting gear. Another perk is that, with natural light, you can avoid using flash, which can startle and distract young children.

LEARNING TO SEE LIGHT

Time and time again, students have shown me work in which the subject looks fantastic and the posing is terrific but the lighting is completely wrong. They intuitively know that there is something about the photo that's not quite right, but they can't put their finger on it. Yes, learning to see light is a skill—and, unfortunately, no digital camera can find great light for you.

Beautiful light is best described as light that travels across an object, creating highlights and shadows so that the object appears three-dimensional to the viewer. We live in a three-dimensional world where the objects we encounter have width,

Good light will help you create a dimensional feeling in your images. Photos by Marc Weisberg.

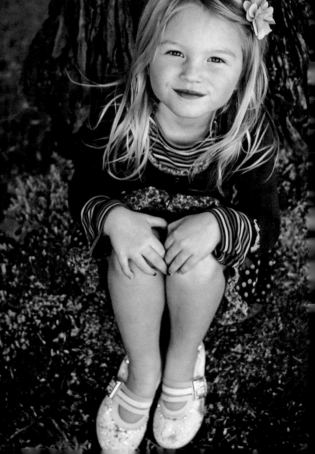

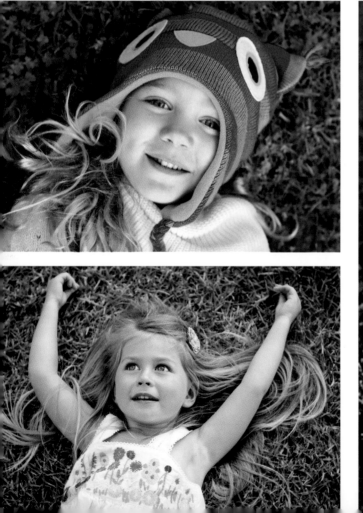

Unique locations are a great fit for lifestyle portraits. I wasn't able to photograph this teen on this lot, but just positioning him in front of it allowed me to produce images with an edgy feel.

■ CREATING MEANINGFUL IMAGES

Today, there's a trend toward more relaxed, spontaneous portraiture—lifestyle images made in a meaningful, natural, or offbeat location.

When looking for great locations for lifestyle portraits, start in your own neighborhood—or the client's. Don't overlook the possibility of working right in the backyard. Often, new photographers and hobbyists go to a great location, expecting to immediately take wonderful photos without doing research. It rarely happens. Practice your lighting approach in your own area. With practice, it will be much easier to go out on location and find soft, usable light.

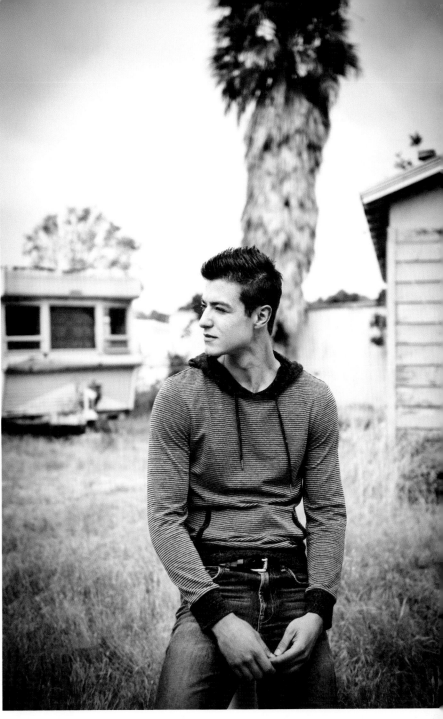

length, and depth. Paintings, drawings, and photographic images, on the other hand, are two-dimensional. To create a feeling of depth and form, the artist must use highlight and shadow. To take advantage of those subject-sculpting highlights and shadows, however, you'll need to learn about the qualities of light and how to modify and harness light. Let's get started.

HARD AND SOFT LIGHT

Hard Light. Hard light is created by a source that is intense, strong, and small in size. It produces hard-edged shadows, deep contrast, bright colors, and bright highlights. Hard light that comes from above (e.g. midday sun) is the worst offender, as it creates unflattering dark shadows under the subject's eyes and nose. The same shadows would result if you hung a bare lightbulb above your subject's head. If you held the unmodified bulb to the side of the subject's nose, you would see a harsh shadow line on the cheek. Hard light is not ideal for portraits—particularly portraits of children. It is often used to produce dramatic and unusual images, and those are qualities not well suited to the innocence of childhood. If you choose to use harsh directional light, I suggest it come from the side or front of the person's face in order to highlight the eyes.

Hard light can be modified and made usable. Sunlight can be diffused and softened by clouds. You can also use an overhead block, like a tree or a porch roof, to block hard light.

Soft Light. Soft light is ideal for portraiture. Such light comes from a larger light source relative to the subject. Outdoors, natural

Hard light that comes from above is the worst offender . . .

Soft light is flattering for portraits of subjects of all ages. Photo by Ally McKay.

This gorgeous, soft light was found under a bridge.

In a scenario when you're forced to shoot in broad daylight, your best bet is to find open shade.

light is soft when the sun is low in the sky, as it is just before and after the sun rises and sets. At this time of day, the sun's rays travel horizontally rather than from above, so no harsh shadows are produced on the subject's face.

In a scenario when you're forced to shoot in broad daylight, your best bet is to find open shade—an area that offers soft, full, bright, directional light. You can find open shade under a tree, next to a building, in an archway, under a canopy, on the front porch—anyplace where overhead light is not directly falling on the subject.

THE INTENSITY AND DIRECTION OF THE LIGHT

The intensity of light varies. To achieve a good exposure and record shape-defining highlights and shadows, you will need light of a particular intensity. A light meter can help you to measure the intensity of light, but it won't find the "right" light—lighting that is just soft enough and coming from the right direction—that's

something you must learn to identify yourself—whether you're shooting indoors or out.

For portrait photography, you want light that is soft and full. When you walk into a home with large windows, pause and look around at the direction of the light. If you scan the room, you will notice areas where objects seem to have a greater intensity and dimensionality; these subjects are illuminated by light with the desired intensity. You will also be able to spot areas where objects seem to have a dull tone; this is because the light has a low intensity. Finally, you will see areas where direct light is striking an object or area. The light is too intense, too bright, and detail is obscured by strong highlights and deep shadows.

When teaching students how to see light, I give them an exercise: I ask them to go into a park-like setting and look for the three distinguishable intensities of light. Once they find light with the right intensity for a portrait, I have them look for the appropriate direction of light. I ask them to turn their hand up to the sky and slowly tilt their palm. I tell them that when the lines on their palm are most pronounced—when the creases and crevices can be easily seen—they've found beautiful light. I still check for beautiful light this way, both indoors and out. There are times when I walk into an area that I believe has great light only to look at the palm of my hand to see it is actually very flat.

GOLDEN LIGHT AND SUNSET

The best outdoor light is found around sunrise and sunset. Photographer Jason Romero has taken hundreds of family portraits on the beach over the years. He likes to shoot 20 minutes before sunset to capture what he calls "golden light." He feels that the shadows produced by the sun earlier in the day are too harsh. His goal is to have the client able to comfortably look into the sun so he doesn't have to use flash.

Romero shoots most of his images at an ISO of 400 on aperture priority. When the sun is low, he uses an ISO of 800 with a wide-open aperture. He feels that this approach allows him to create the most beautiful natural light images.

Marc Weisberg also prefers to work just before sunset. He too feels that careful positioning of the subject is critical to creating a

■ PRACTICE

Take your camera and photograph areas with low light intensity, perfect intensity, and high intensity. Download the images and study them so that you can learn to recognize the different intensities of light the next time you encounter them. First look for directional light that is hard and creates large white areas where the sun falls directly on the object. Then look for areas of deep shade where objects appear gray and are almost indistinguishable from the environment and background. Finally, look for open shade where the objects have a dimensional feel.

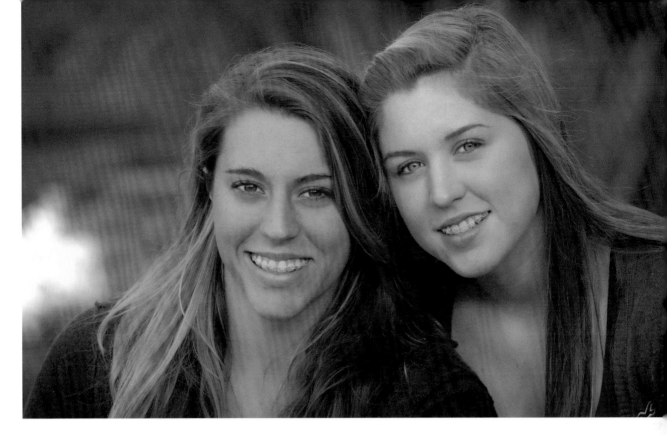

The best outdoor light is found when the sun is low in the sky—right around sunrise and sunset.

beautifully lit portrait. Marc turns his subjects slightly toward the direction of the setting sun. He feels that when the sun is setting, the sky is like a big softbox.

USING REFLECTORS, SCRIMS, AND BLACK PANELS

Sometimes photographers find that the light they encounter on location isn't usable as is. Fortunately, light can be modified for better results.

Reflectors. When the light level is too low in a scene, photographers sometimes introduce a reflector to redirect light in the scene so that it is bounced onto the subject. Store-bought reflectors come in several colors, including silver, gold, white, bronze, white gold, soft silver, and more. Reflective cards (e.g., white poster board or a similar item) can be used as well.

Reflectors bounce light from another source onto the subject to fill shadow areas with light.

Not all reflected light is equal. The distance from the reflector to the subject will determine, in part, the intensity of the reflected light. So will the size of the reflector itself. The color of the reflector can affect the color of the light that strikes the subject. Silver reflectors, for instance, throw light with a cooler look onto the subject, while warmer light is produced by a gold reflector.

Scrims. A scrim is a device that's placed in front of a light source to diffuse it and reduce its intensity. Scrims come in handy when working with natural light, as they can make hard light softer and more usable.

Black Panels. Black panels are another great light modifier for location photographers. This tool is positioned between the light source and the subject to block or reduce the light that is striking the subject.

WINDOW LIGHT

I love using window light in a client's home or in my natural light studio. I look for a large window that provides soft, full light that reaches the subject area and is intense enough to fill the room with

Black panels are another great light modifier for location photographers.

TOP—A scrim is placed between the light source and subject to diffuse harsh light and reduce its intensity. BOTTOM—Here, a black panel placed to the left of the subject blocked unwanted light. It can also be used to create a shadow side in a flat-light scenario.

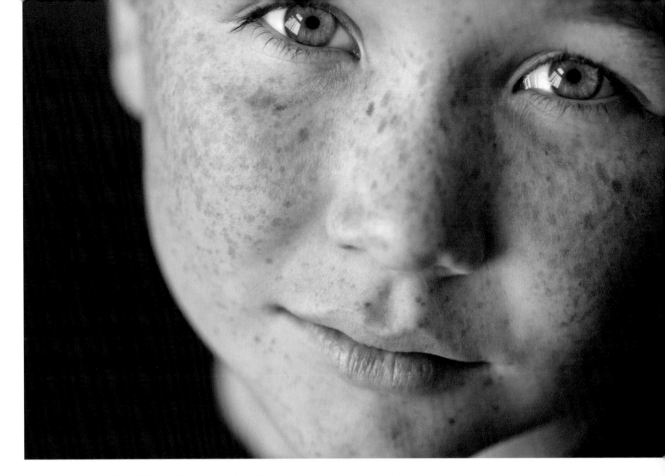

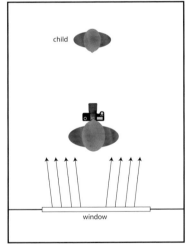

TOP—Full, soft window light creates a wraparound effect that flatters the features and creates a sense of dimension. ABOVE—This diagram shows the ideal subject placement for window-light portraits.

light. The best results are achieved when the sun's light comes from above the window and bounces into the room, not when it pours directly into the window and onto the subject. Full, soft window light will wrap around the subject, falling off (i.e., diminishing in intensity) on the shadow side to create the desired dimensionality in the portrait. When the sunlight comes from a higher angle and bounces around the room, the effect is similar to the lighting look produced by a softbox.

The best window light is found on the second storey of a building. This light has no obstructions, and its color is typically not contaminated by trees, buildings, or cars. The ideal window is about 10x5-feet high and 1 to 3 feet off the ground. At that height, there is a natural falloff of the light, which can be used to vignette the scene. When light comes from a window that is more than 3 feet from the floor, much of the subject will appear too dark. To address that problem, pose the subject on a chair or riser to elevate them. When using window light, always place the subject at the edge of the window farthest from your camera.

FLASH FILL

Sometimes natural light needs a helping hand. When your background is too bright or the subject is backlit, you may want to add off-camera flash, set at a low power, to throw just a little more light on the subject, filling in shadows.

LIGHT RATIOS

When lighting subjects for portraits, one side of the face is typically lighter than the other. This side is called the highlight side. The opposite side is darker, of course. It is called the shadow side. The highlight side is illuminated by the main light. The shadow side is illuminated by fill light. The intensity of the light illuminating each side of the face is described using a light ratio.

When you photograph babies and young children, flat lighting (a 1:1 ratio, with both sides of the face equally bright) works well. This type of lighting is best used for high-key portraits, or with portraits in which the background is light in color. More dramatic lighting, for instance, a 3:1 light ratio, looks best with older children and teens. When using a higher light ratio, a dark background helps to accent the dramatic lighting.

■ FLAT LIGHTING

Babies and young kids look great when illuminated with flat, frontal light, as their features are very soft and round. Older children can also be photographed with flat lighting; a three-dimensional look can be produced when the light travels from the side. Once I have identified a location with good light, I ask the child to step into the area and to let the light shine on their face. Kids love to help you create something.

Flat, frontal lighting is more flattering for very young subjects than it is for older kids, teens, and adults.

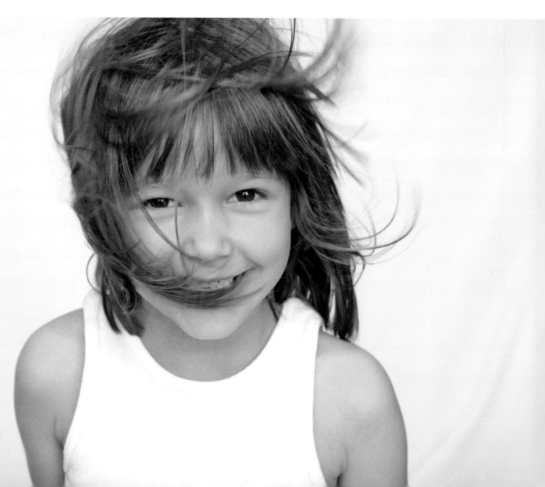

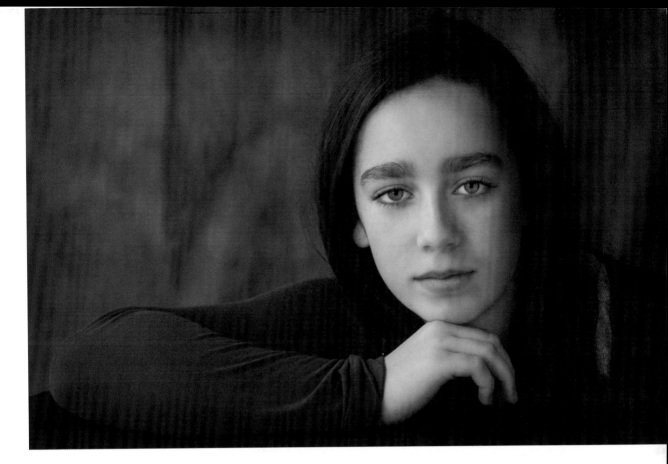

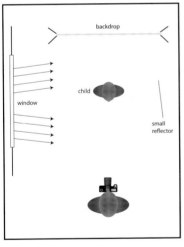

The lighting ratio for this image was 4:1, a ratio that works well for a low-key portrait.

Understanding Light Ratios. Let's imagine you have a subject posed for a window light portrait. She is seated at an angle to the window. The side of her face close to the window is lit by the main light (the light that streams through the window, directly striking her face). Any light that comes through the window but does not strike her face lights her surroundings, bouncing throughout the room. This light—the fill light—lights the side of her face that is turned slightly away from the window. Because the light illuminates the entire room and she is seated in the room, both sides of her face receive fill light, but only one side is illuminated by the main light.

Let's plug in some numbers. Numerically speaking, the fill light would provide 1 unit of light on the highlight side of the face and 1 unit of light on the shadow side of the face. The main light would provide 1 additional unit of light on the highlight side of the face. Therefore, the highlight side would receive 2 units of light. The ratio would be 2:1.

When the main light is 1 stop more intense than the fill light, a 3:1 light ratio is produced. This is because the main light provides

Set your white balance! In a park setting, the grass and trees can create a green cast in your images (this is most pronounced in the shadows). Photo by Marc Weisberg.

2 units of light (the light is twice as bright) and the fill light provides 1 unit of light on each side of the face (2+1:1 = 3:1).

COLOR TEMPERATURE AND WHITE BALANCE

All light has a color temperature. Sunlight, for example, measures about 5500 degrees Kelvin, and tungsten light measures about

■ LOCATION SUCCESS

1. Open fields, rustic build-
 ings, urban settings, brightly
 painted walls, and commer-
 cial development areas make
 great backdrops for environ-
 mental portraits.
2. For park or beach locations,
 bring a blanket for the child
 to sit on.
3. Look for light that softly
 illuminates the subject area.
4. Use a wide-open aperture
 and long focal length (e.g.,
 f/2.8 aperture with a 200mm
 lens) to compress the scene
 and blur the background.
5. Add light with reflectors for a
 more natural look.
6. Use fill flash only when
 necessary to balance a bright
 background or eliminate
 unflattering shadows.
7. When the light is waning,
 select a higher ISO and the
 widest aperture possible to
 "take in" as much natural
 light as possible.

Beautiful portraits require beauti-
ful, color-cast-free skin tones.
Here, the subject's rosy complex-
ion is not impacted by the sur-
rounding foliage. Photo by Marc
Weisberg.

3200 degrees Kelvin. The higher the Kelvin temperature of the source, the bluer the light appears. The lower the Kelvin tempera-ture of the source, the redder the light appears. Our eyes neutral-ize these color casts, but to produce color-cast-free images, we need to use an on-camera control called white balance.

Most professional-level digital cameras offer an automatic white balance setting and a variety of white balance presets that will help you produce color-correct images. In mixed light scenarios, or for the most accurate results possible, create a custom white balance.

13. POSTPRODUCTION

When shooting digitally, we don't have to limit the number of frames we shoot. This freedom comes at a price, though: we find ourselves left with a surprisingly high number of images to work with in postproduction. Because postproduction can be time-intensive, and time is money, it makes sense to develop a workflow that can streamline the process.

I break my postproduction work into three phases: (1) downloading and archiving, (2) processing the images, and (3) retouching and enhancement.

DOWNLOADING AND ARCHIVING

I like to capture my images in RAW+JPEG mode. The RAW format allows for greater flexibility in making post-capture corrections and enhancements than the JPEG format affords. JPEGs come in handy when, for one reason or another, I don't have the time to process a RAW session before sharing proofs with my client.

After a session, I immediately back up my images. Using Adobe Photoshop Lightroom, I save copies of my RAW+JPEG files to three locations—a hard drive, flash drive, and DVD. It's important to keep a backup drive off-site (consider cloud storage) as added insurance in the event of fire, flood, or other unanticipated event.

PROCESSING THE FILES

Processing in Lightroom has revolutionized my photography. Years ago, a fellow photographer, Dennis Mock, said that Lightroom completely changes the look of your images. He was right.

■ ARCHIVAL TIPS

1. Immediately download and archive your image files after your session.
2. Ensure your image backups are saved in two or three places. DVDs, external hard drives, flash media, and cloud storage are a few methods.
3. Create a system for easy retrieval of your images. Label your files using names, dates, or a numeric system that makes sense to you.
4. Never erase or format your camera's memory cards until your original files have been backed up to at least two places.

TOP—You can easily improve an image—even using the simplest image-editing software. In this case, blemishes and under-eye circles were retouched using iPhoto. **BOTTOM**—Here's the iPhoto image-editing interface.

■ BASIC RETOUCHING FOR THE HOBBYIST

Basic retouching can help you enhance your images for a more professional look. If you don't have access to professional-grade image-editing software like Adobe Photoshop, you can use the software that came bundled with your camera or computer. If you're using a Mac, try iPhoto; it's a helpful program that can be used to retouch the skin, take out red-eye, enhance the color, and convert the image to black & white or other monochromatic tones, and crop the image. You can also adjust the color and sharpen the images for a more finished look. There's an iPhoto app available for iPad2 and later models. For information on using iPhoto, go to www.apple.com/support/iphoto.

Adobe Photoshop Elements is another program that many hobbyists favor for retouching. It offers much of the functionality and power of Adobe Photoshop, but it costs far less.

One thing I like about Lightroom is that I can flag multiple images and assign ratings. This helps me isolate my first-pick images—the one I want to share with clients. I can also group my second- or third-choice images, making organization a breeze. Once I've flagged and rated my images, I back them up to an external drive or DVD and make the required corrections.

I feel that RAW images have a gray, dull quality; they don't seem to have the clarity that film negatives have. I always enhance the sharpness, clarity, and luminosity of each file. For most images, I also enhance the vibrance or color saturation. Lightroom also allows for making exposure and white balance corrections when the need arises.

Presets. Once my basic enhancements are made, I use presets to enhance and/or add creative effects to my portraits. Lightroom comes with some presets, but you can also record your often-used processing steps and then play them back to process a batch of images with just the click of a button (similar to Photoshop's actions). You can even share and/or trade your presets with other photographers.

Processing Time. Before Lightroom, it would take me up to 9 hours to process an average order. With practice using Lightroom, I can process a portrait session in just 75 minutes. Lightroom not only expedites my processing; it has also improved the quality of my images.

BASIC LIGHTROOM

Once you open Lightroom, you will need to import your files. If the images you wish to edit are on a hard drive, you will need to go to File>Open and select your files. Alternatively, you can connect your camera to your computer via a USB cord, or you can insert the camera's memory card into a card reader. (When you choose one of the latter two options, an Import window will open in Lightroom. You will be given the option to import or simply add them.)

The import dialog box allows you to attach metadata and key words to your files. I use the metadata to add my copyright information to each file. (*Note:* You can fill in your copyright information in Lightroom's Library mode.) To do so, go to the Metadata tab, select Edit Metadata Presets, fill in your information, and save it with a custom name.

After importing your images, select your favorites. You can do this using the P key, or you can use one of the many filters available to select photos in groups. I then work only on the images I have selected—usually my favorites and second picks.

Next, I move on to Lightroom's Develop module. Here, you can manipulate the image without destroying the original. I like to sharpen the images and add clarity and a little Luminance. For most images, I also adjust the white balance, add some brightness, then sharpen. Finally, I add Lens Vignetting to the majority of portraits.

■ LIGHTROOM'S CATALOGS

Many photographers use catalogs to organize their images by subject or year. I use this approach myself. If you don't know much about Lightroom or catalogs, go online and watch some tutorials or pick up Scott Kelby's book, *The Adobe Photoshop Lightroom 4 Book for Digital Photographers* (Peachpit Press, 2012).

■ WARNING!

When you download images from your camera and the battery runs out of juice, you run the risk of losing your images. I strongly suggest that you import from a card reader or from a folder. A card reader can be purchased fairly inexpensively from any camera store or electronics retailer. You will find the most use out of a card reader that accepts several different sized cards from micro, SD, to CF cards. When it comes to card readers I have found to spend just a little bit more will give me a card reader that lasts longer and doesn't damage my cards.

These screen shots show some of what's possible when using Lightroom to process your images.

Presets. Once my basic enhancements are made, I download the images and back them up. In the Develop mode, simply click Create Virtual Copy in the Photo Mode section. If you'd like to make copies of multiple files at once, press and hold the control button, right-click your mouse, and select Create Virtual Copies

Whether you're creating a great montage for a teen's album or a display-worthy portrait, you'll find the actions Lightroom offers will lighten your workload when it comes to postproduction.

from the pop-up menu. It may take a minute for Lightroom to create the copies.

At this point, you are ready to apply one of Lightroom's actions to your copied image(s). Experiment with the presets. Select the photo you want to apply an effect to, then click on the preset. If you like the change and want to apply it to a series of images, select the desired files. Select the Sync button when the Develop module box appears. Make sure that you want the settings displayed to be applied to all the images. I currently have Lightroom 3, and I like to use the High Contrast B&W Creative Preset and Color Creative–Bleach Bypass preset, among others.

To create your own Preset, simply make custom adjustments to your image, then click the "+" at the top of the Preset menu. Name your preset, and save it into a folder you create. Presets can be downloaded and shared with other photographers and transferred to updated versions of Lightroom.

BASIC RETOUCHING

The Skin. Most kids have great skin, so minimal retouching is required. Try the following approaches when necessary:

Most kids have great skin, so minimal retouching is required.

Kids' portraits should appear natural, never over-retouched.

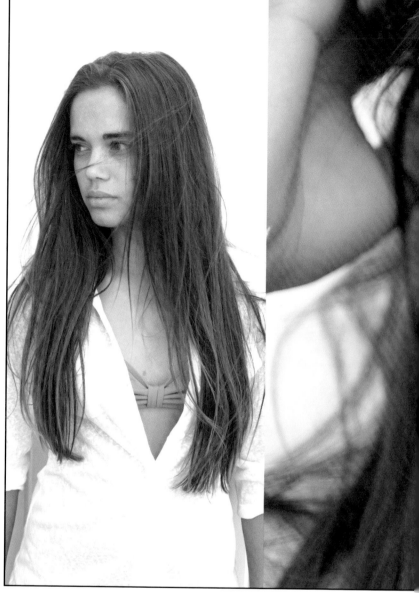

TOP AND BOTTOM LEFT—Teens' portraits may need a little more retouching than younger kids' portraits require, but the results should look natural. Here, I used the Healing Brush tool on the boy's skin and finished with a skin-softener action. RIGHT—Take a little time to make the subject's eyes pop. After all, the eyes are the focal point of the portrait.

- In Photoshop, use the Healing Brush to remove blemishes and reduce the wrinkles under the eyes.
- Soften the skin using a third-party plug-in or filter (e.g., Nik Software Color Efex Pro's Dynamic Skin Softener filter) or the Unsharp Mask filter in Photoshop.
- Use Nik Software's Tonal Contrast to smooth the skin and add a warm tone (alternatively, you can use Photoshop's Hue/ Saturation feature to add warmth).

The Teeth. Take some time to whiten the teeth, but be sure not to over-whiten. A too-white smile looks unnatural. To whiten teeth

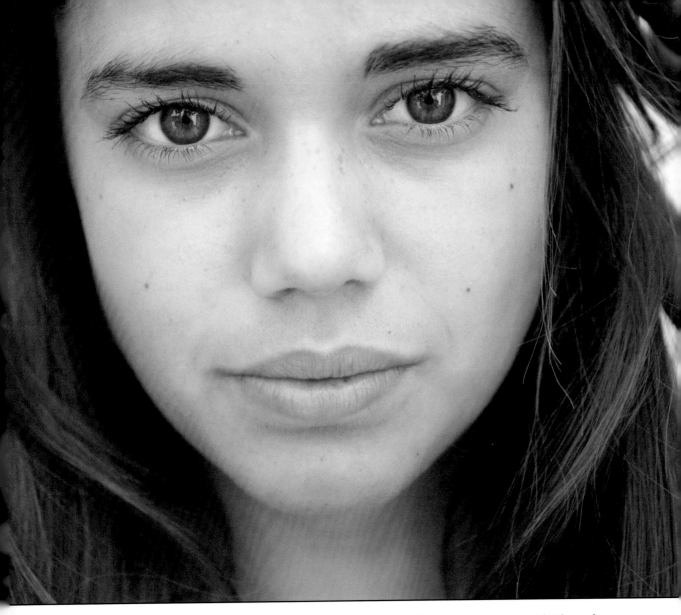

quickly and easily, you can use the tools that come with Photoshop or use actions or plug-ins. There are several third-party action sets that will accomplish many of the retouching tasks in a single click. I use Intuition Envy Action Set from www.jensfabulousstuff.com for most of my facial retouching. These actions can be used to enhance skin, teeth, hair, eyes and clothing. For portraits of adults, I use the Intuition action called Hollywood Smile, but for children's portraits, I like to digitally dodge the teeth or select a low opacity and paint over them with a white brush to brighten them.

The Eyes. One way to make your images pop is to enhance the child's eyes. Using the Burn tool at a very low opacity—say

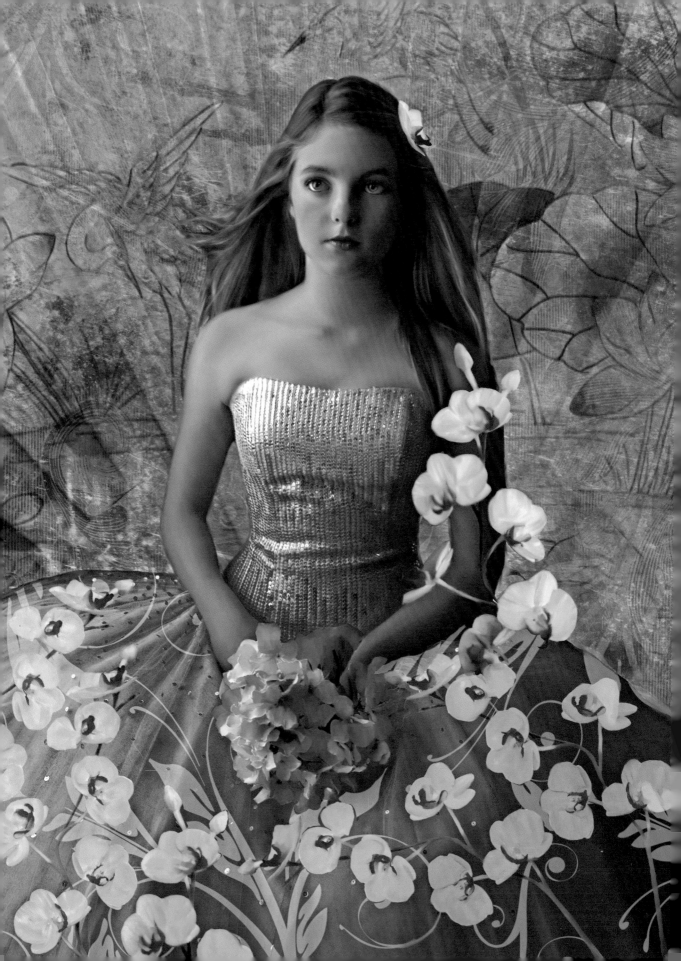

6 to 15%—trace around the edges of the irises and the eyelashes. To brighten the whites of the eyes, try using the Dodge tool at a low opacity setting. If that is not enough, try a white paint brush at about 10 to 30% opacity and paint over the white areas of the eyes. The Bright Eyes and Sparkle in Your Eyes actions are another option. (These are also part of the Envy action set.)

Finishing the Image. To finish the image, vignette the edges (try Kevin Kubota's Artistic Action II, Edge Burner). I save every image as an unflattened PSD file, then make a copy of the file, flatten it, and save it as a JPEG. Many third-party actions flatten the image automatically. In this case, I save a version of the image with every completed retouching step, labeling the changes as I go.

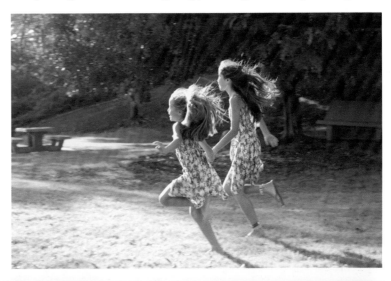

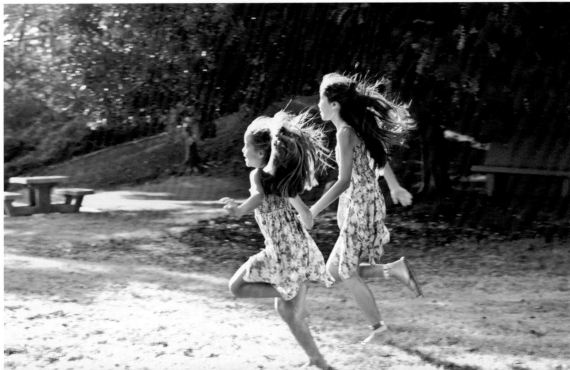

MARC WEISBERG

Everything starts with a clean capture. I shoot 100% RAW. That's just how I roll. Light is the key ingredient and a dead-on, sharp exposure is critical. I typically shoot my children's outdoor portraits in manual at f/2.8 if I'm using a fast, 50mm f/1.2 lens and f/4.0 if I'm using a 70–200mm f/2.8 IS lens. Since outdoor lighting conditions vary and my aperture remains constant, the shutter speed and ISO vary depending on the situation. On occasion, I use a light meter to ensure my exposures will be correct, but more often, I rely on my camera's histogram reading.

My general approach is to focus on the eyes and recompose. My camera is not mounted on a tripod. For studio portraits, I shoot at ISO 200 and f/8 at $^1/_{250}$ second.

My initial culling is done in Photo Mechanic, where I delete any images that I don't like and rename my files. Then I import my images into Lightroom and adjust the color temperature, exposure, black point, clarity, and saturation to taste—and possibly add a vignette too. After my images are tweaked, I output them as JPEGs (for images up to 20x20 inches at 180dpi). If I need very big prints, I'll go back into Lightroom for the original RAW file and output it to the size needed. If your exposure was close to dead on and your image was tack sharp, you're 95% of the way there.

To add the final polish to my portrait, there are five things I do in quick succession. (*Note:* I use a Wacom Intuos tablet for all of my retouching.)

1. Remove any blemishes with Photoshop's Healing Brush. I remove excessive bags or under-eye shadows by creating a duplicate layer and using the Patch tool to sample the skin just below the lower-eye area. Once the sampling is done and the area is retouched, I reduce the layer opacity to 50%.

2. Imagenomic's Portraiture is my go-to plug-in for retouching skin. This Photoshop-compatible plug-in has a built-in algorithm that affects the skin and not the eyes. (However, it does affect the hair, clothes, and the background to some extent. For this reason, I use it in mask mode.) It's easy to overdo it and have plastic-looking skin with not a pore left on the face. To keep it looking realistic, I drag the layer opacity slider back to about 50%.

3. Using the Dodge tool, I'll dodge the whites of the eyes with a 6% opacity using a soft round brush. If needed, to make the eye color pop just a bit more, I'll dodge the iris to open up the color. The final

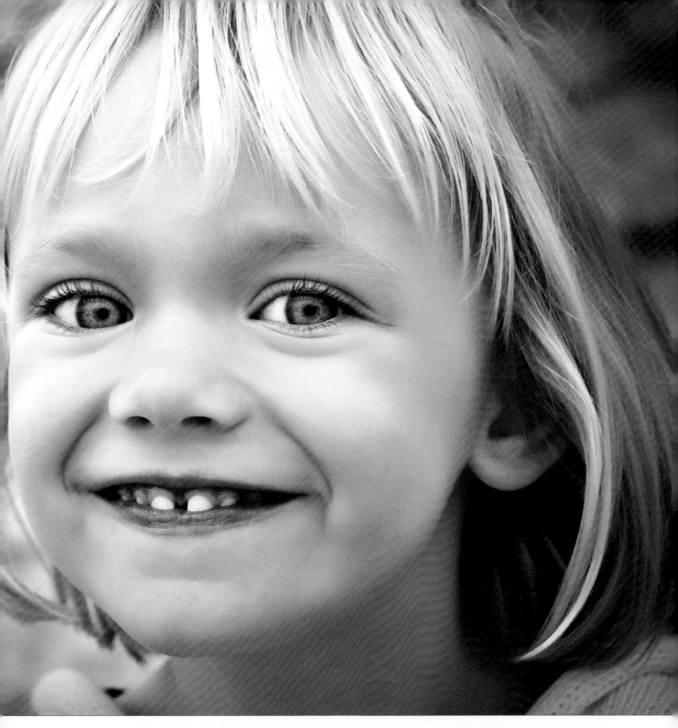

step is to use the Sponge tool, set at 6% opacity, and lightly add saturation to the iris.

4. There are a few ways to whiten the teeth. You can use the Lasso tool with at least a 5-pixel feather setting, then create a Hue/Saturation adjustment layer to reduce the color intensity of any color cast. Another option is to use the little-known Teeth Whitening brush in Adobe Lightroom. In the Develop mode, click on Brush>Exposure>Teeth Whitening. It works wonderfully.

5. Finally, I add a vignette to the image. This can be accomplished in Adobe Lightroom or Adobe Photoshop. I use both. Depending on the image, I'll apply anywhere from a 20% Vignette to a 50% Vignette using Post-Crop Vignetting (accessible by expanding the Effects tab in the Develop module). The final touch is to add a bit more vignetting for added drama. For this, I use Photoshop's Rectangular Marquee tool with a feather setting of 200 pixels. (Photo by Marc Weisberg.)

14. CONCLUSION

Professional photographers, and the portrait industry itself, have seen dramatic change in recent years. Digital technologies have made it easier than ever for the layman to take a decent picture, and the availability of camera phones has made it even simpler for people of all ages and backgrounds to take photographs of their loved ones. These photographs are readily shared on social media sites. The faltering economy has prompted more individuals

Getting to know your subjects, gaining their trust, and creating images they'll cherish are just a few of the perks of children's portrait photography.

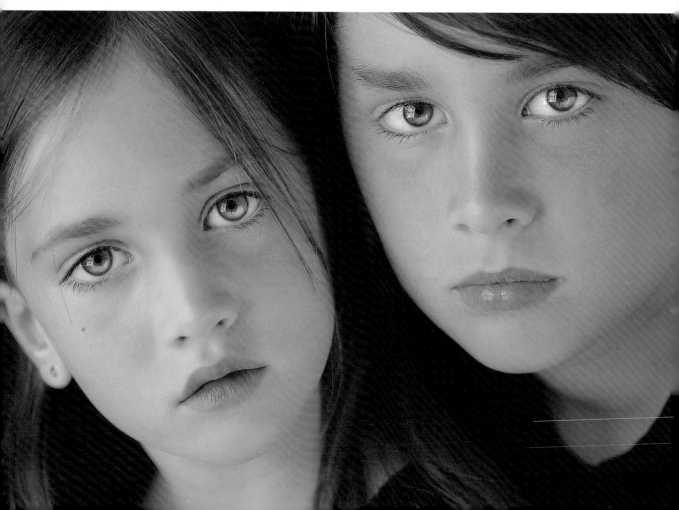

The combination of clothing, setting, composition, and expression make this image unique. A postproduction treatment can boost the overall impact.

■ RESOURCES

Use the resources out there to make your business successful. A few worth checking out are:

www.photobizcoach.com
Beate Chelette's web site is dedicated to educating photography professionals about the business.

www.5figurephotography.com
This site is dedicated to teaching photographers how to earn more income.

www.Facebook.com/jeff.lubin
Check out Jeff Lubin's Portrait and Business Tip of the Day, along with his many workshops and DVDs.

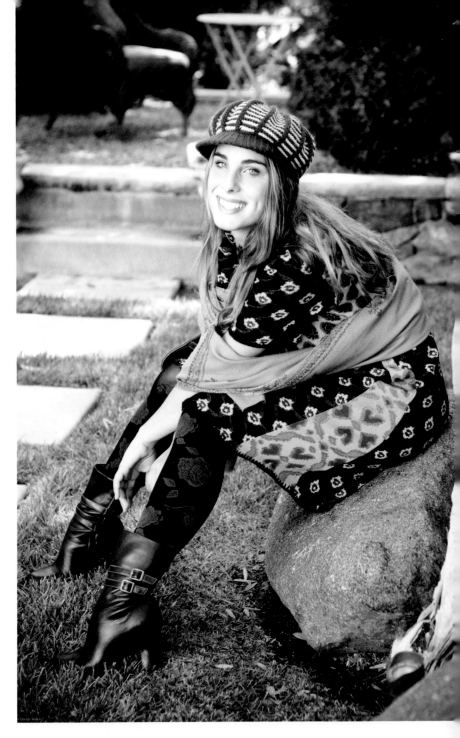

to try their hand as professional photographers. The photography market has become oversaturated, and it is now harder than ever to make a living as a children's photographer.

To thrive in this industry, you'll need to set your work apart from the others. You'll need to take a step back and see why your

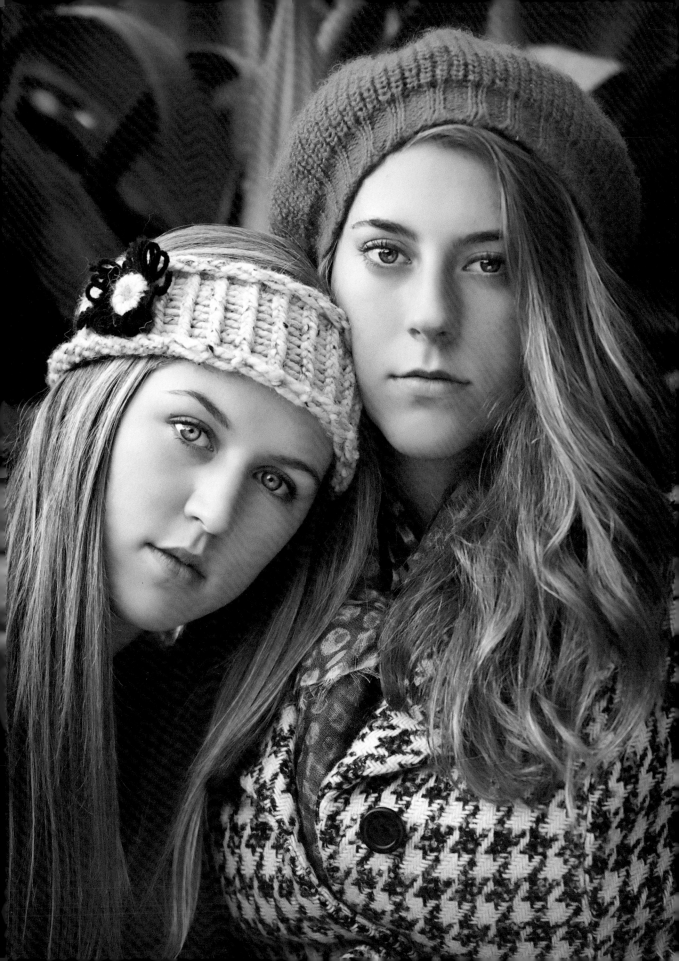

clients would come to you instead of some other photographer. When you've identified that reason, spotlight it. Create a brand that tells the public what you're all about; let them know how and why your business is special. Take that brand and build your web site, logo, business cards, and business plan around it. Do your research to make sure your brand is well suited to the market you are trying to reach.

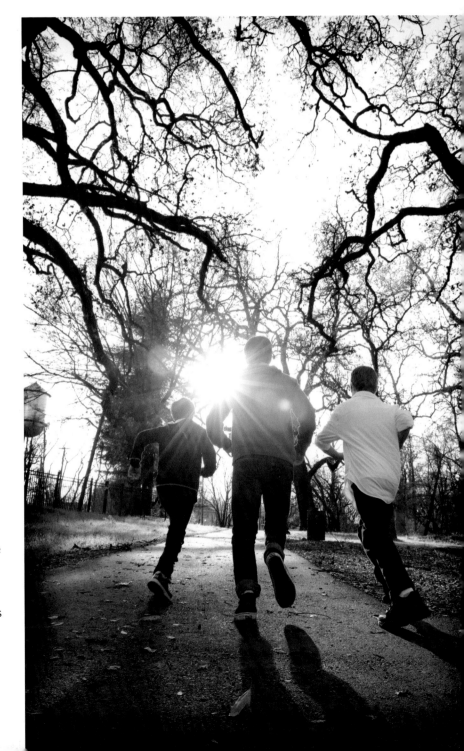

In lifestyle portraits, the faces of the subjects are not always visible. The goal is to capture a moment that tells who the individuals are and what they are about. The three brothers in this image are close and very playful with each other. They live in a rural area, and this image speaks volumes about their life.

ABOUT THE CONTRIBUTORS

KAY ESKRIDGE

www.imagesbykay.com

Kay Eskridge is the owner of the Arizona-based Images by Kay & Co. Photography, a studio with a sterling reputation. As a lifestyle portrait artist, Kay's clients rely on her to document their special events and milestones—from maternity and newborn images to portraits of toddlers, school-aged kids, and teens. She even photographs family vacations. Her focus on relationships, creative approach to children's and family portraiture, and unique and clear vision of business have allowed her to achieve much success doing something she loves.

JUDY HOST

www.judyhost.com

Judy Host has won numerous awards for her photography. She has been featured in several publications for her outstanding environmental portraiture. She was featured in *Rangefinder* magazine in 2004 as one of "Today's Top Children's Photographers." She was also featured in a July 2011 *Rangefinder* article entitled "The Soulful Portrait." Her work has been selected for national exhibition by the Professional Photographers of America (PPA). Judy received her Masters and Craftsman degrees from PPA. She has received three Kodak Gallery Awards. Many of her images have been exhibited at Epcot Center and are part of a traveling loan collection.

MICHELLE LIPOWSKI

www.reflectionsml.com

Since 1990, Michelle has photographed thousands of children and families who enjoy her playful portraits showing the wonderful nature of children. She is best known for her outdoor portraiture, and in 1993 she established her "Bunnies & Babies" spring portrait special benefitting the Juvenile Diabetes Research Foundation. She has since raised more than $50,000 for the cause, teaming up with professional photographers throughout California. Michelle was certified as a PPA Professional Photographer in 1998.

REBECCA LOZER

www.rebeccalozer.com

Rebecca Lozer is a children's photographer who excels at showing her young subjects as they really are—vulnerable, happy, and sometimes silly. She has some formal training, lots of hands-on experience, and is continually working to build upon her skill set. She has devoted a great deal

of time to understanding and manipulating light. She loves the light-hearted, candid fun that photography offers.

DAVID AND ALLY MCKAY

www.mckayphotography.com

David and Ally McKay are two of the nation's most awarded photographers. Both hold the title of Master Photographer from PPA and have received numerous awards throughout their prestigious careers. David and Ally are nationally recognized speakers, and their work has appeared in numerous publications and on television.

TERRI RIPPEE

www.rippeekids.com

A third-generation artist in a family of photography enthusiasts, Terri has earned a loyal following over the years. She photographed her first wedding over fifteen years ago; seven years later, she quit her position at a printing company to pursue photography full-time. She shares a studio with three other talented photographers, but most of her sessions are photographed on location.

JASON CHARLES ROMERO

www.jasoncharlesromero.com

Jason Charles Romero is a fine-art photographer and educator. He has collected PPA's Award of Excellence on numerous occasions and has also been named Photographer of the Year and Image Maker of the Year. Some of his images are on display at the Los Angeles County Museum of Art. Jason continues to strive to push the limits of creativity and imagination in his craft.

MIKE STRICKLAND

www.disneyeventphotography.com

Mike Strickland began his creative career as an actor performing on-stage and on-screen. Over 20 years ago, while acting for a major entertainment company in central Florida, he turned his eye to photography. He returned to school to study the technical aspects of photography, and he took every seminar and class available. Mike is always looking to share his knowledge and abilities with fellow artists; he regularly conducts seminars and serves as a mentor to help the next generation of photographer reach their goals.

KIM TREFFINGER

www.treffingerstudio.com

Kim Treffinger is an award-winning, formally trained fine artist who lives in San Diego, CA. She is recognized for her digital painting techniques and has long been known for her artistic passion for a range of mediums. Kim was featured on HGTV's *Crafters Coast to Coast* and has shown her work locally and nationally. She is a member of PPA, and she holds a degree in design from the University of California—Davis.

MARC WEISBERG

www.marcweisberg.com

Marc owns and operates a boutique photography studio in Irvine, CA, and specializes in magazine-style photography of newborns, babies, children, and families. He is the recipient of 16 coveted international awards for photographic excellence. You'll find his work featured in over a dozen books on Amazon. His photographic passions have taken him to Paris, Copenhagen, the Mexican Riviera, Los Angeles, San Francisco, Cuba, New York, and Stockholm.

INDEX